IN FOCUS

CARLETON WATKINS

PHOTOGRAPHS

from

THE J. PAUL GETTY MUSEUM

The J. Paul Getty Museum

Los Angeles

In Focus
Photographs from the J. Paul Getty Museum
Weston Naef, *General Editor*

© 1997 The J. Paul Getty Museum
1200 Getty Center Drive
Suite 1000
Los Angeles, California 90049-1687

Christopher Hudson, *Publisher*
Mark Greenberg, *Managing Editor*

Library of Congress
Cataloging-in-Publication Data

Watkins, Carleton E., 1829–1916.
 Carleton Watkins : photographs from the J. Paul
Getty Museum.
 p. cm. — (In focus)
 ISBN 0-89236-399-1
 1. Photography, Artistic. 2. Outdoor photogra-
phy. 3. Watkins, Carleton E., 1829–1916.
4. West (U.S.)—Pictorial works. 5. J. Paul Getty
Museum—Photograph collections. 6. Photograph
collections—California—Malibu. I. J. Paul Getty
Museum. II. Title. III. Series: In focus (J. Paul
Getty Museum)
TR652.W38 1997
779'.092—dc21 96-29761
 CIP

Contents

Foreword

Carleton Watkins was the logical choice for the first book in our In Focus series devoted to a nineteenth-century American photographer. The large body of his work at the Getty Museum is among our strongest holdings, and Watkins is a historical figure of consuming interest. He arrived in California at the time of the gold rush, but instead of heading for the hills in search of riches, he worked first as a carpenter and bookseller, then turned to photography. He soon lost interest in studio portraits and spent the rest of his life working outdoors. He became famous for wrestling his seventy-five-pound camera, along with hundreds of pounds of glass and the chemicals for sensitizing and developing the plates on the spot, into some of the highest and most remote places in the state. He also made hundreds of other photographs using smaller cameras that allowed him to experiment more spontaneously with different subjects and viewpoints. This book focuses on the latter pictures, which have never before been gathered together in this way.

Watkins's life and work were discussed in a colloquium at the Getty Museum on February 23, 1996, which provided part of the text for this book. The participants included Tom Fels, Weston Naef, Peter E. Palmquist, David Robertson, and Amy Rule, as well as David Featherstone, the moderator of the conversation and condenser of the transcript.

We are grateful to Mr. Palmquist for providing the interpretive texts for the plates and to Anne M. Lyden, who coordinated the efforts of the many people who contributed to the final product. There were others, in addition to those listed on the last page of this book, who were involved in the project: Julian Cox, Ted Panken, Charles Passela, Jean Bruce Poole, Jean Smeader, Rebecca Vera-Martinez, and Fred Williams. To them and to Weston Naef, who devised the In Focus series and continues as its general editor, I offer my thanks.

John Walsh, *Director*

Introduction

Carleton E. Watkins (1829–1916) stands today at the symbolic apex of all that is unreservedly grand about the American West of the mid-nineteenth century. An immigrant from a small village in upstate New York, Watkins embraced his new California home with a lover's passion. He is perhaps best remembered for the technical and artistic excellence of his images of Yosemite—images characterized by the oft-repeated statement: from the "best general view." Competing photographers marveled at his ability to make these pictures in a wilderness setting with a tiny dark tent (see back jacket) as the only amenity.

The J. Paul Getty Museum holds more than 1,400 photographs by Watkins, 187 of which were made from so-called mammoth plates, very large glass-plate negatives approximately eighteen by twenty-two inches in size. While Watkins is best known for these grand images, this volume focuses on his smaller works, including stereographs and prints in cabinet and boudoir formats. These pictures reveal a photographer whose scope of work went far beyond the dramatic, Edenic landscapes that first brought him fame.

Photography almost always changes the context of the subject being photographed. Transferring photographs to the pages of a book changes this context even further. For example, the picture reproduced on the front jacket of this book is of a monumental landscape. Watkins made a photograph of the scene that is approximately five inches in diameter. A photograph of this image was reduced to roughly

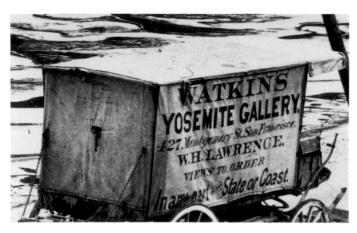

Carleton Watkins. *Rooster Rock, Columbia River*
(pl. 38, detail), 1883.
Albumen print, 12.1 × 20.5 cm.
92.XM.99.8.

four inches in order to fit on the front jacket, yet the picture reads as a majestic composition regardless of its comparatively small size. The context is also determined by the perspective of the photographer—the viewer sees what the photographer wants the viewer to see. Changes in the artist's viewpoint, or even equipment, change the entire picture. An example of this is provided by two of Watkins's works, a mammoth plate of the Columbia River (p. 119) and its corresponding stereograph (pl. 16). (Stereographs, which are meant to be viewed as a pair in a stereoscope, are reproduced in this volume as a single image.) In the context of this In Focus book, the selected pictures have been arranged chronologically and formatted to fit the page size of the series. The result is a portable exhibition of photographs that relate to each other on purely aesthetic terms.

In spite of significant decontextualization, the views selected for this book convey a unity of perception and the well-ordered workmanship and attention to detail that have come to symbolize Watkins's singular eye. As John Coplans, a long-time Watkins enthusiast, states: "Although a photographer cannot invent to the same degree as a painter, the detailing within a Watkins photograph...is so carefully ordered that it *appears* to be under the same kind of control."

Watkins's photographic career spanned more than fifty years, and his travels covered thousands of miles: from British Columbia in the north to the Mexican border on the south; westward to the Farallon Islands off of San Francisco and eastward as far as Yellowstone. There were very few subjects that were outside the scope of his camera. He photographed lumber mills and lavish mansions in California, railroads in Oregon, smelters in Nevada, and prehistoric ruins in Arizona. His work took him to the top of Mount Shasta in 1870, where he was plagued by glare ice, and to the bottom of a Montana copper mine in 1890, where he suffered horribly from dampness and vertigo. He often journeyed by train, with his horse-drawn "traveling wagon" (p. 6) carried on one flatcar and his living quarters on another. Not only did he create outstanding visual documents for his clients, he was also a major chronicler of the commercially developing West.

Watkins has, in the judgment of many, emerged as the single most important American photographer before Alfred Stieglitz. Weston Naef, commenting on this evolving appreciation, has maintained that Watkins "had the uncanny ability to choose the best point from which to view any particular subject and the power to structure his photographs as an interconnected web of relationships that are about the act of pure perception." A master artist? Yes, but also an enigma and a contradiction for his biographers. It is known that Watkins immigrated west in 1851 to make a new life for himself and that he became a portrait photographer by accident when asked to fill in for an absent camera operator, a role he filled successfully from 1854 to 1856. One can only speculate, however, as to the steps that led to his commitment to outdoor photography. Throughout his working life, Watkins won international acclaim for the excellence of his photographs, yet he died in poverty and was interred in an unmarked grave. Although his photographs of the Pacific Coast were considered the finest of their kind, he lost many of his negatives to a competitor and had his life's work destroyed in the 1906 San Francisco earthquake and fire. Well known in the 1860s, Watkins's pictures slipped from view until the 1960s. It is even difficult to know with certainty what Watkins looked like, his image being captured more in shadows (p. 8) than in portraits.

In many ways, the ongoing investigation of Watkins's life and work resembles an archaeological dig. Under ideal circumstances, a biographer will have access to a photographer's business records, photographic archives, and personal

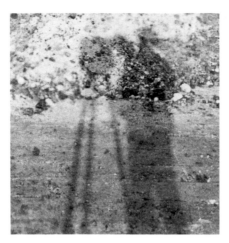

Carleton Watkins. *View of Wharf of the Selby Lead*
and Silver Smelting Works, San Francisco, Cal.
(pl. 25, detail), circa 1874.
Albumen stereograph, 7.9 × 7.7 cm. 96.XC.25.5.

papers. Sadly, all were obliterated in the 1906 disaster. Consequently, most of what is known about Watkins today has come by way of accumulated bits and pieces of information, which, when cobbled together, can lead to conclusions of fact. The best source of information has proven to be the photographs themselves, which form a sort of visual diary of where and when he traveled. Because there is no comprehensive catalogue of his output, researchers are always on the lookout for new or potential examples. One such archaeological fragment, attributable to Watkins, may well be the earliest surviving outdoor photograph made by him (see p. 93).

In Watkins's heyday a mammoth-print photograph sold for $3.50 and stereographs were $5.00 per dozen, when and if he could find a buyer. "More of an artist than a businessman," it was said, yet he adamantly refused to lower his standards, even when competition from mass production caused the price of a dozen stereographs to fall to $1.50 and bankruptcy was inevitable. Thus, despite the tragic overtones of Watkins's personal and financial life, his photographs stand today as a timeless tribute to one man's persistent and indefatigable pursuit of his art.

Peter E. Palmquist

Plates

Note to the Reader

Stereographs, which are
meant to be viewed as
a pair in a stereoscope, are
reproduced in this volume
as a single image. Plate 3
reproduces both halves of a
stereograph.

Where possible, names
of works have been assigned
based upon Watkins's own
inscriptions, printed titles
on stereograph cards,
and captions in his albums.

Plates 20–22 are gifts in
memory of Leona Naef
Merrill and in honor of her
sister Gladys Porterfield.

PLATE I

Mechanics' Institute
1860

Albumen stereograph
7.3 × 7.4 cm
84.XC.902.51

When viewed through a twin-lensed ste-
reoscope, the two images of a stereograph
pop into three dimensions, providing a
highly detailed picture full of visual infor-
mation about the event, place, or object
shown. Carleton Watkins made stereographs
by at least 1859 and perhaps earlier. This
image documents a stand at the Third San
Francisco Mechanics' Industrial Exhibition.
The fair provided a unique opportunity
to display agricultural and manufactured
products in a public setting. Watkins
most likely recorded this presentation for
potential sale to the exhibitor.

One of Watkins's most unifying trade-
marks is his unerring ability to create
visual order out of scenes filled with a host
of distracting details. This still life is full
of information: an advertising broadside for

Ero-Vapor Stoves, framed certificates, and
rows of oil lamps and wood- or coal-fired
stoves. At the top are the decorations
and open beams of the pavilion hall. The
foreground, dominated by the white table
skirting, is softened by the competing
elements in the lower-right corner. The
image was captioned and signed in Watkins's
own hand.

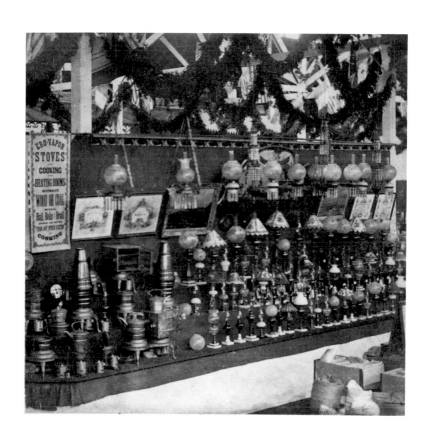

PLATE 2

Union Mass Meeting, Market, Post and Montgomery Sts., S.F., Cal.

Circa 1880 albumen
copy of a print from
a February 22, 1861,
negative
15.2 × 18.9 cm
96.XM.26

Watkins is not generally credited for his work as a chronicler of everyday events, yet he regularly documented newsworthy happenings in San Francisco, among them the launching of the ironclad *Comanche* (1864), the aftermath of a massive nitro-glycerin explosion (1866), and the wreck of the *Viscata* (1868). He also produced significant photographs of local Fourth of July activities between the years 1862 and 1876 (see pl. 9). However, he did all of this before the technology of reproducing photographs in newspapers was developed.

The pro-Union gathering shown here attracted an estimated fourteen thousand people and was the largest public gathering recorded in California up to this time. Parades, brass bands, oratory, and gala decorations were the order of the day.

While this image was issued as a "Taber Photo" (see p. 58) about 1880 and bears a printed inscription of July 1860, it was Watkins who made the original negative in 1861. He captured the "best general view" from his elevated position, a trait that characterized his landscape work as well. Once again it is his attention to detail, such as the grouping of four men in the left foreground, that best demonstrates his authorship of this photograph. Watkins's own politics are unknown, but, being from New York, he was most likely a Union supporter.

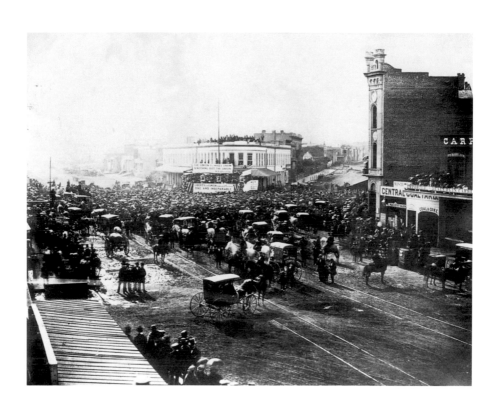

PLATE 3

Yo Semite Falls.
2630 ft

1861

Glass stereograph
6.2 × 15 cm
92.XH.97.1

Watkins's beginnings as an outdoor photographer probably date from as early as 1856 (see picture on p. 93). By 1858, when two of his photographs were used in a court case involving a land dispute, he was already making wet-collodion negatives. The following year he honed these techniques while photographing John C. Frémont's Mariposa estate. The commission to document the mining facilities there required him to produce a large number of roughly twelve-by-sixteen-inch prints as well as stereographs.

Watkins made his first trip to Yosemite in the summer of 1861. In order to capture the cathedral-like qualities of the valley, he had a large camera constructed—one that would take eighteen-by-twenty-two-inch negatives—and fitted it with a lens designed especially for landscape photography. He made at least thirty mammoth negatives and approximately one hundred stereographs, such as the one shown here. His stereoscopic images, in particular, reveal his preoccupation with the foreground as a defining element of space in landscapes. Although Yosemite Falls is the principal subject of this photograph, the cabin (with its interplay of sunlight and shadow) and the strongly vertical trees greatly add to the three-dimensionality of the picture.

Stereographs were often purchased in sets and were intended to be viewed as a group. They were so important in the mid-nineteenth century that in 1859 Charles-Pierre Baudelaire was moved to remark that "a thousand hungry eyes were bending over the peepholes of the stereoscope, as though they were the attic-windows of the infinite." In many ways, stereographs were the television of the era.

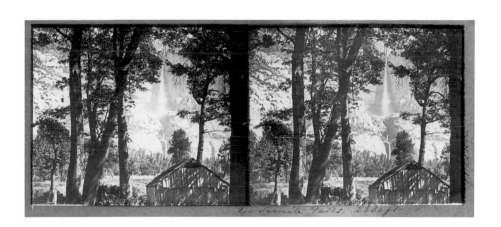

Yo Semite Falls, 2630 ft

PLATE 4

"Inverted in the Tide Stand the Grey Rocks"

1861

Glass stereograph

5.5 × 7.3 cm

92.XH.97.2

As an avid reader who enjoyed novels, history, and travel accounts, Watkins sometimes employed literary analogies in his correspondence and captions. Amy Rule has identified the verse inscribed under this picture as being from Henry Wadsworth Longfellow's 1824 poem "An April Day."

Watkins never tired of experimenting with the infinite patterns of nature: juxtapositions of water, land, sky, and foliage; observations of light and dark, positive and negative, large and small, soft and hard. Yosemite became a lodestar for him, and he followed its beckoning beam for twenty years. In this image of the Three Brothers reflected in the Merced River, Watkins has actually inverted nature and reconfigured the relationship of "grey rocks" in terms of both sky and foreground areas. It is instructive to compare this stereograph half with the mammoth-plate *River View, Cathedral Rocks* (pl. 5). Both contain the same visual elements, yet the mammoth view is a far more "classic" Watkins arrangement—cerebral and orderly, with a well-defined progression of foreground elements culminating in a monumental object. The smaller work appears more picturesque. When examined together, however—the stereograph enlarged and shown as a single image, the mammoth plate reduced to the same relative scale— the vision and passion remain the same. This is most obvious if plate 4 is inverted. Watkins regarded the two formats as having different functions (and audiences) and generally reserved the use of metaphorical titles, such as the one provided here, for stereographs, which were intended for a more popular clientele.

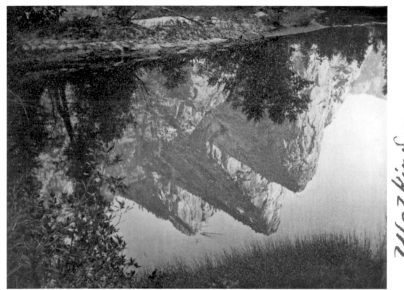

"Inverted in the tide
Stand the grey rocks." Yosemite

Watkins —

PLATE 5

River View, Cathedral Rocks

1861

Albumen print
39.8 × 52.7 cm
85.XM.361.30

This mammoth-plate image is immense, at least by comparison with the standard size of a stereograph half such as plate 4. Both pictures were taken with a wide-angle lens, but the intent of the mammoth photograph is to produce a sense of awesome grandeur, like a painting hung on a wall. The vision is far more painterly as well. This is especially true in that Watkins has articulated three distinct layers of space: foreground, middle ground, and background. Whereas the sky serves to outline and cradle the main feature, Cathedral Rocks, the foreground elements lead the eye to the dominant object.

Most critics of the period were unanimous in agreeing that it was Watkins's masterful use of light that best distinguished his Yosemite photographs from those of lesser artists. This dome-topped print is typ-ical of mammoth work printed by Watkins before 1865. It is unclear whether the cropping was done to remove a technical problem or for reasons of style. By 1862, examples of Watkins's mammoth Yosemite prints had been placed on display in the windows of the prestigious Goupil's Art Gallery in New York, where they were widely admired.

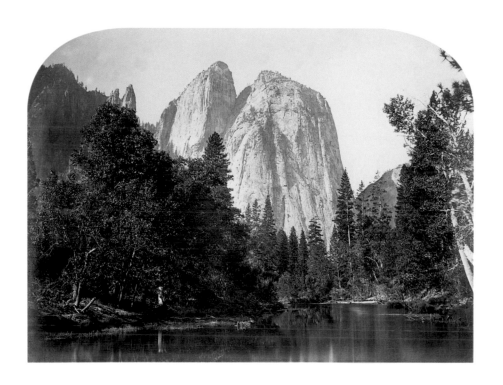

PLATE 6

Big River Mill from the Pt.

1863

Albumen stereograph
7.8 × 7.5 cm
96.XC.25.1

Not only is this photograph a dynamic land-
scape composition, it also contains a sur-
prising self-portrait. The shadows cast at
left create the only known likeness of Watkins
with both his mammoth and stereoscopic
cameras. Self-portraits by nineteenth-century
photographers are rare, especially in a
Western landscape genre. While this one is
subtle, it is hardly an accident. Watkins
and his equipment appear in a number of
the images reproduced in this book, and
many more are known. Sometimes it is a
lens or a tripod that is seen within his
viewing frame (see back jacket); other times
it is a shadow (pl. 25) or traveling wagon
(pl. 38) that serves as his "fingerprint."
Interestingly, there are only two known
studio portraits of Watkins: a cameo bust
by Pietro Mezzars (p. 90), and a cabinet
portrait taken by an unknown photographer.

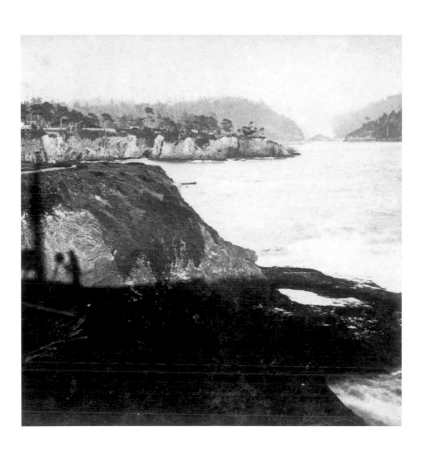

PLATE 7

Black Point, San Francisco

Circa 1864

Albumen stereograph
7.9 × 7.6 cm
84.XC.979.9393

PLATE 8

At the Cliff House, San Francisco

Circa 1882 albumen
stereograph from
a circa 1865 negative
7.9 × 7.8 cm
84.XC.902.99

Stereographs were a major stock-in-trade for the tourist market (much like the photographic postcard of this century). Watkins's inventory included all of the sightseeing spots in San Francisco, often from a series of different vantage points. Customers could purchase a selection of the twin-imaged cards for their home stereoscope or select unmounted stereograph halves for pasting into their travel albums. These two stereo views are of popular coastal locations.

Photographing the nude in a landscape has become a cliché, particularly in California photography, yet *Black Point, San Francisco* (pl. 7) is one of the earliest known examples of this practice. It was made approximately twenty years before Frank Sutcliffe's *Water Rats* and Thomas Eakins's photographs of boys at a swimming hole in Pennsylvania. Even as late as the 1920s, Anne Brigman's nudes were considered controversial, primarily because her subjects were cojoined with landscapes.

This image is essentially timeless and might just as well have been titled generically *Seascape with Children.*

The curving lines in the picture are echoed by those in *At the Cliff House, San Francisco* (pl. 8). A total of four different structures, each known as Cliff House, have stood on a site overlooking the Pacific Ocean at the northwest tip of the city, not far from the entrance to San Francisco Bay. The area has been a popular tourist destination for more than one hundred years. This is a view of the first Cliff House, built in 1863.

Watkins has used the twisting lines of the dirt road and stone wall to lead the viewer directly to the location. The austere rock face on the right intrudes onto the scene, skewing the approach to the house. When viewed in a stereoscope, the image has a particularly powerful three-dimensional impact.

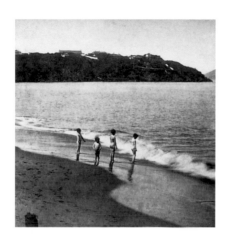

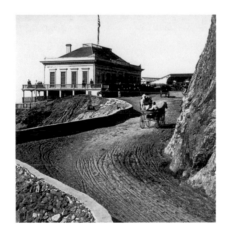

PLATE 9

Montgomery St., from Austin's Building, July 4, '65, S.F.

Circa 1869 albumen
stereograph from
a July 4, 1865,
negative
7.5 × 7.7 cm
84.XC.902.59

Watkins liked to photograph crowds (see pl. 2) and did so in ways that express the excitement of an event at a time when photography was not a spontaneous art. In this case he was working from either the roof or an upper window of the Austin Building at 425 Montgomery Street, which housed his studio. Fourth of July celebrations were among the most popular festivals for San Franciscans; Watkins photographed them when he was in town, notably in 1862, 1864, and 1865. He made an even more extensive series during the Centennial activities of 1876.

The striking sense of instantaneity is the most dominant element of this picture. Watkins has arrested motion and frozen time. He has stilled the flags flapping in the wind and placed the parade and its spec-tators in a time capsule. Both Watkins and New York photographer Edward Anthony, another master of this type of photography, often made a special point of labeling such work as "instantaneous." This way of making pictures, using the uncap/recap method of exposing the plate, was uncertain at best. A midday scene, specially sensitized plates and developers, and quick reflexes were required. This interest in stopping movement presages Eadweard J. Muybridge and his motion studies, which led to the development of the motion picture.

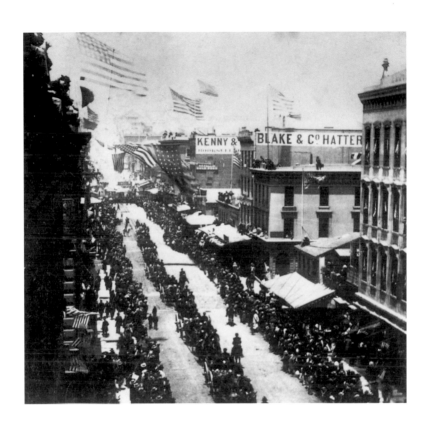

PLATE 10

Vase of Flowers

Circa 1865

Albumen stereograph
7.6 × 7.6 cm
84.XC.979.9394

An inscription on the back of this stereo-
graph card reads: "Vase of flowers presented
to Mrs. Wadsworth (wife of Revr. Chas.
Wadsworth) by M. E. A." In 1865, Reverend
Charles Wadsworth was pastor of the Calvary
Presbyterian Church in San Francisco.
Since Watkins had been raised a Presbyterian
and may have attended Wadsworth's
church, it follows that he would have been
the most logical candidate to memorialize
the elaborate flower arrangement. Watkins
was an excellent choice for this type of
task for other reasons as well. He had pho-
tographed both two- and three-dimensional
artworks in a wide variety of venues and
had created many still lifes by focusing
on details from nature in Yosemite. During
the 1870s Watkins became the photog-
rapher of choice for producing interior
and exterior architectural studies of lavish
San Francisco estates.

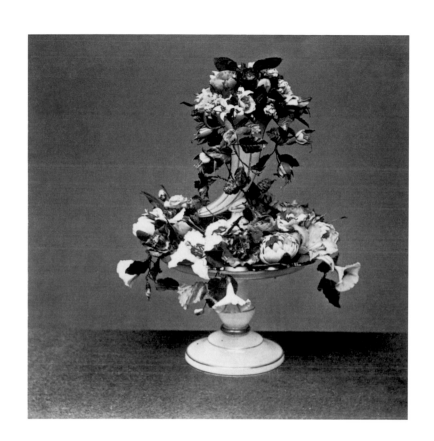

PLATE 11

From the "Best General View," Mariposa Trail

1865–66

Albumen print
19.4 × 29.5 cm
84.XO.199.4

Watkins's long association with the California State Geological Survey began in the early 1860s. In 1865 and 1866 he joined the survey for its summer work in Yosemite. Although he was a significant addition to the team, there was no money to pay him as an employee. He was compensated instead for photographs used for survey reports and for such utilitarian tasks as copying maps. The survey leaders, Josiah Dwight Whitney, William H. Brewer, and Clarence King, all famous geologists, also did their best to encourage sales of Watkins's photographs to other scientists and institutions such as Harvard and Yale. Their 1865 trip commenced in early July; Watkins's equipment reportedly consisted of some "2,000 lbs. of baggage" with enough "glass for over 100 big negatives."

Watkins was legendary for his skill at finding the point from which a subject should be seen in order to reveal the most about its content, whether it be a lumber mill or an awesome natural form. He believed this view contained the "best" inventory of Yosemite's major features: Bridalveil Fall, Cathedral Rocks, Half Dome (in the distance), and El Capitan (at left). It was photographed in both mammoth and stereoscopic formats as well as the size pictured here. This is a bold image, one that represents Watkins's growth as an artist of landscapes. Of particular interest is the strong, vertical tree, audaciously cut off at top, which not only provides a sense of drama but also draws the eye inward toward the more central elements of the view. An instructive comparison is provided by Charles Leander Weed's photograph of the same scene (p. 112).

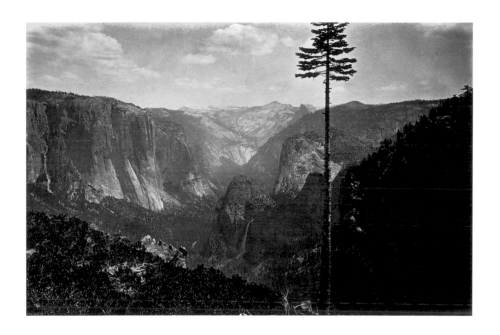

PLATE 12

The First View of
the Valley from
the Mariposa Trail

1865–66

Albumen print
19.4 × 29.5 cm
84.XO.199.3

This striking image, a particular favorite of J. D. Whitney, is a perfect visual representation of Horace Greeley's reaction made during a trip to Inspiration Point in Yosemite in 1859: "My friends insisted that I should look over the brink into the profound abyss . . . but I, apprehending giddiness, and feeling the need of steady nerves, firmly declined." It is hard to imagine where Watkins was standing when he made this photograph, since the camera seems to be suspended in midair.

Photographer Charles Roscoe Savage, who visited Watkins in 1866, was amazed at his ability to produce so many quality negatives "in a climate so dry and difficult to work in," and observed: "After so much attention to photographic ware, porcelain, rubber, and other materials for making [processing] baths, I found his to consist of pine wood coated heavily with shellac. . . . His negatives are taken, developed, and then placed in the water bath until he is ready to finish them. Just think of carrying such huge baths, glasses, etc., on muleback, and you can form some idea of the difficulties in the way of producing such magnificent results."

Near the middle of the composition is a barely discernible, doughnut-shaped optical softness. This was caused by internal reflections within Watkins's wide-angle Globe lens and represents one of the difficulties of landscape work before the development of antireflective coatings.

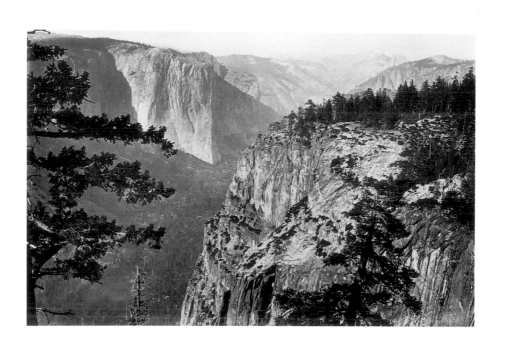

PLATE 13

Tutocanula Pass

1865–66

Albumen print
29.5 × 19.4 cm
84.XO.199.45

The sky nearly always plays an essential role in Watkins's landscape work. He was a master at balancing his exposures to reinforce the compositional building blocks that he desired, notably featureless skies and shadow detail in even the very darkest areas. Yet, in this picture, it is probably the impressionistic light reflecting off a field of greenery in the foreground that is most intriguing.

Early in 1866 Watkins sent six of his new Yosemite images to Edward L. Wilson, editor of *The Philadelphia Photographer*. Wilson's enthusiasm for the photographs was absolute: "At no time has our table been graced and favored with such a gorgeous contribution." Encouraged by such praise, Watkins later assembled leatherbound albums of his views under the title *Watkins' Yosemite Gallery*.

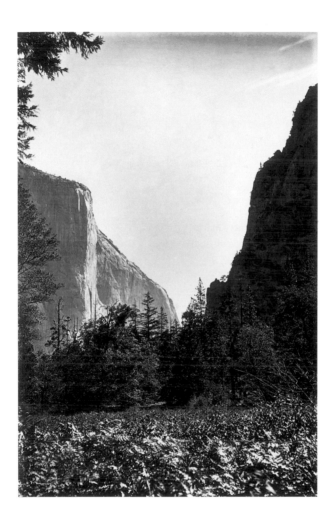

PLATE 14

**Panorama of
San Francisco from
Telegraph Hill,
Washington Square**

Circa 1866

Albumen stereograph
7.5 × 7.7 cm
84.XC.979.9533

Landscape photographers were frequently preoccupied with the problem of how to show the relationship of objects that were too far apart to be seen together in a single picture. One solution was to make a series of images, which, when joined together, created a panoramic overview. Watkins made panoramas in several different formats, most covering a viewing angle of about 180 degrees. However, since this image is the nineteenth in a series, it probably was part of a 360-degree sweep of San Francisco. Such a panoramic series, when displayed one after the other in a stereoscope, enabled observers to gain exactly the same sense of the city as if they had personally stood on Telegraph Hill.

There are at least eleven surviving multiplate panoramas of San Francisco dating from the daguerreian era, which Watkins would surely have known and which may have influenced his series.

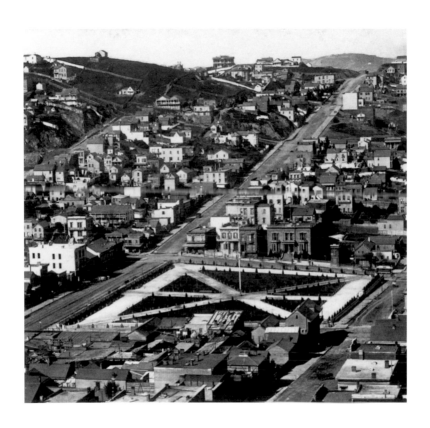

PLATE 15

Docking the Steamer China, Hunter's Point Dry Dock

Circa 1867

Albumen stereograph
7.9 × 7.9 cm
84.XC.979.9553

San Francisco, only connected to the East
by the Pony Express in 1860 and by the
transcontinental railroad in 1869, prided
itself as being a crossroads for shipping.
The city had excellent dry-dock facilities,
such as this one at Hunter's Point. The
China resembles a bird resting in its nest.
The use of a wide-angle lens greatly en-
hances the nesting qualities by reinforcing
the curvature of the dry dock's structure.
The three-dimensional effect is heightened
by the placement of the camera at the
steamer's bow, taking full advantage of the
rapidly retreating lines of sight. Even
the cable attached near the ship's anchor
becomes a powerful element in the overall
stereoscopic look. Watkins's sensitivity to
the beauty of machine forms was far ahead
of his time.

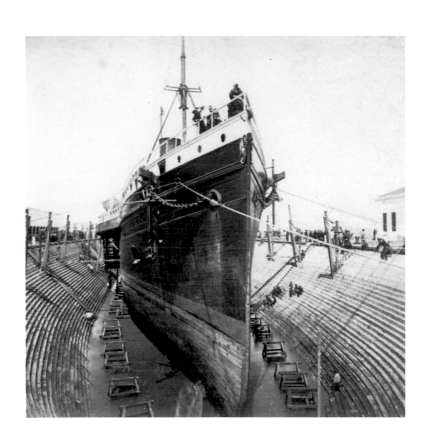

PLATE 16

Cape Horn,
Columbia River

1867

Albumen stereograph
8 × 7.6 cm
96.XC.25.3

The year 1867 was especially paradoxical for Watkins. Although his reputation continued to grow (he received his first European recognition at the Paris International Exposition), he was unable to meet all of his expenses. J. D. Whitney, who had hoped that Watkins would travel to Oregon, voiced his deep concern: "Watkins is as poor as he can be of late. He told me that he had only received $2.50 in 20 days," adding that "Ashburner [one of the survey members] thinks he is a completely 'played out' man." Despite his own financial worries, Whitney loaned Watkins enough money for the trip north.

One of the principal goals of the expedition was to obtain photographs of the geology of Oregon, including the chain of extinct volcanic mountains that cap the coastal range. A second client was the Oregon Steam Navigation Company's railroad, along whose route Watkins traveled. He made at least fifty-nine mammoth negatives and more than one hundred stereographs during his Oregon visit.

The photograph shown here and a mammoth plate of the same scene (p. 119) are among Watkins's most memorable compositions. Both images were made within a short time of each other and have virtually the same content, yet there are subtle but unmistakable differences. Even when reproduced at the same relative size, the mammoth print appears more classic, casting the lone figure at the symbolic edge of awesome nature. In the stereograph, the dog and the two men in quiet conference help to create a sense of man's control over his environment. This harkens back to the intended purposes of and audiences for the two images. The mammoth print was to be viewed as wall art, hung grandly in a salon. The stereograph, by contrast, was planned specifically to be more participatory—seemingly transporting the observer into the scene.

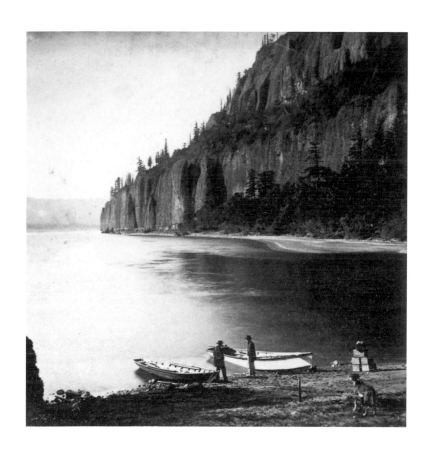

PLATE 17

**Effects of the
Earthquake, Oct. 21,
1868, Railroad House,
Clay St.**

Circa 1880 albumen
stereograph from
an October 21, 1868,
negative
7.9 × 7.8 cm
84.XC.902.98

The October 21, 1868, earthquake was one of California's largest nineteenth-century natural disturbances. Fortunately, property damage was limited, because the epicenter was east of San Francisco in an agricultural region. Destructive scenes such as this one presage the devastation of the April 18, 1906, San Francisco earthquake, which destroyed Watkins's negatives and personal files.

At first glance, this image resembles the back lot of a movie studio, yet a closer examination reveals a unique and vigorous compositional arrangement of great interest. The unstable horizontal lines leave the viewer with an impression of undulation, as though the buildings were still moving. This wavy motion is seemingly arrested and stabilized by the leaning diagonal poles. The horrifying details of disaster and chaos, caused by the violence of the earthquake, are made more immediate by the presence of the two men in the window. Are they victims who have lost their business, city engineers on an inspection tour, or Watkins's fellow photographers and/or assistants out to document the event?

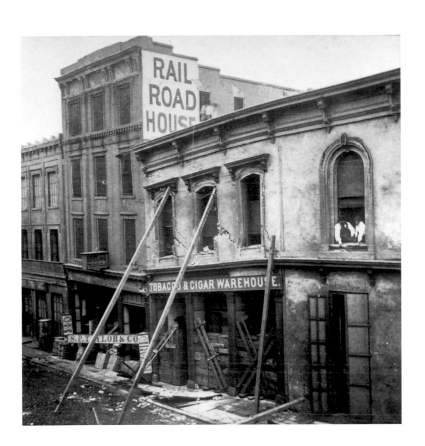

PLATE 18

Golden Gate
from Black Point,
San Francisco
Circa 1869

Albumen print
20.3 × 28.6 cm
94.XM.16

The Golden Gate, the narrow opening to
San Francisco Bay, is not only the entrance
to a safe harbor, it is also a natural defense
for the city of San Francisco. The strategic
importance of the headlands overlooking
the channel was recognized by the Span-
ish; military fortifications were in place
long before California became a state. The
onset of the American Civil War caused
added development and an increased mili-
tary presence, but the defenses were never
tested in battle.

While Watkins is best known for his
wilderness photographs, he was equally
adept at creating urban landscapes of great
power. This picture seems to be a little of
both. The mechanical elements in the fore-
ground are gently echoed by the soft, natural
outlines of the distant promontories. The
quiet water in between forms a serene
background for an inventory of objects that
includes one goat, two soldiers, two can-
nons, three cannon carriages, and a neatly
stacked pile of cannonballs.

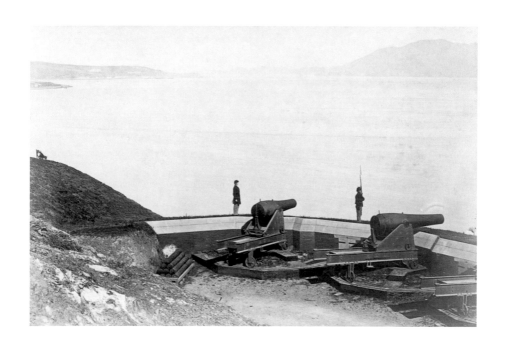

PLATE 19

Chinese Man

Circa 1869

Albumen stereograph
8 × 7.7 cm
84.XC.902.68

This stereograph bears an inscription—
"The Heathen Chinee"—that is an obvious
reference to the popular title of a poem by
Bret Harte. The inscription, in an unknown
hand, does not reflect Watkins's sentiments.
He frequently photographed Chinese resi-
dents of San Francisco (see pl. 23) and
felt comfortable in their exotic environment.

By 1869 Watkins's financial fortunes
were finally on the upswing. His gallery,
now at 429 Montgomery Street, was fast be-
coming a landmark, a must-see for tourists
arriving on the newly completed trans-
continental railroad. He was able to add to
his salable inventory by obtaining more
than three hundred stereoscopic negatives
that had been made by Alfred A. Hart of
the building of the Central Pacific Railroad.

PLATE 20

Sequoia Grove, Calaveras County

Circa 1872

Albumen print
30.5 × 21 cm
94.XA.113.54

The main focus of this photograph is the central tree that has been stripped of its bark. In the summer of 1854 entrepreneur George L. Trask erected a scaffold around the tree, known as "The Mother of the Forest," and removed the bark to a height of 116 feet. It was shipped to New York, where it was reassembled for public display and advertised as "The Tree Mastodon." In 1878 the far-traveled Constance Gordon Cumming wrote of the debarked tree: "I can see her from where I now sit—a ghastly object . . . the St. Sebastian of the forest." Watkins's photograph is organized so as to make a direct comparison between the brutalized redwood and its still-living mates. This makes him one of the first photographers who consciously recorded the harmful impact of man on nature.

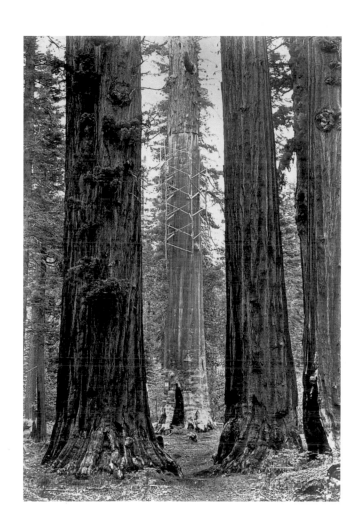

PLATE 21

Mount Watkins,
Yosemite

Circa 1872

Albumen print
31.2 × 20.4 cm
94.XA.113.71

In 1865 J. D. Whitney bestowed Watkins's name on an 8,500-foot peak in Yosemite. The recognition was given as an appreciation for Watkins's work with the California State Geological Survey. Mount Watkins may be the first geological feature named for a photographer (Mount Ansel Adams was designated in Yosemite in 1934). Naming this particular mountain—here reflected by the calm surface of Mirror Lake—after Watkins seems symbolic as well. Not only did he view nature upside down with his camera, because of the inverted perspective of the lens, he was especially interested in photographs of land forms reflected in water, perhaps because this reversed the inversion (see pl. 4).

Watkins was not a purist. This print was cropped from a mammoth-plate photograph specifically to fit a California Tourist Association album. The reason that the reflected image appears stronger than Mount Watkins itself has to do with the way water absorbs ultraviolet light, thereby reducing the effects of atmospheric haze.

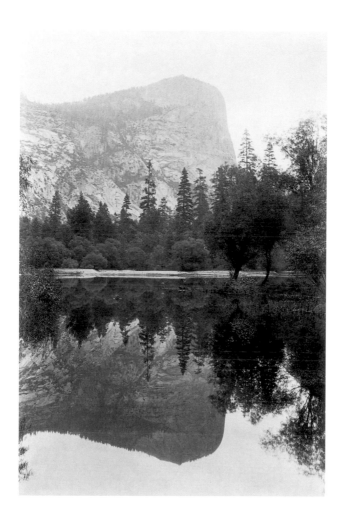

PLATE 22

Sentinel,
View from the Valley,
Yosemite

Circa 1872–78

Albumen print
30.5 × 20.8 cm
94.XA.113.69

One advantage of a very large negative is that prints can be cut down to create new compositions. This photograph, like plate 21, was cropped from a mammoth-size print. Watkins photographed this site along the Merced River repeatedly over a period of twenty years. Seasonal variations, as well as those of water level and foliage development, often created profound differences between visits. In this photograph the fallen tree dominates the foreground, while the Sentinel looms over the middle ground.

By 1872 Watkins had established his Yosemite Art Gallery in San Francisco. The establishment was to be the facility of his dreams but unfortunately had to be built on borrowed capital. His new enterprise was grandly planned: "The walls are adorned with one hundred and twenty-five of those superb views of Pacific Coast scenery (in size 18 × 22 inches) which have given Watkins a reputation world-wide . . . views of almost everything curious, grand or instructive." His rise in San Francisco's burgeoning cultural establishment is marked by his participation in organizing the San Francisco Art Association.

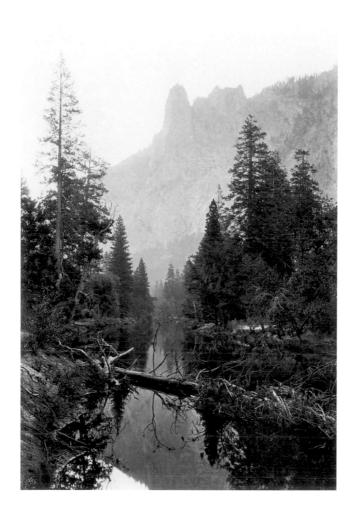

PLATE 23

Bartlett Alley, Chinese Quarter

Circa 1880–90 albumen print
from a circa 1873 negative
12.7 × 8.4 cm
84.XO.250.35

During the 1870s and 1880s Watkins
made numerous studies of San Francisco's
Chinatown and its inhabitants (see pl. 19).
He apparently had friends in the Chinese
community; the area was only a few blocks
from his studio on Montgomery Street.
His body of Chinatown work includes for-
mal portraits of prominent Chinese indi-
viduals (mostly taken indoors) as well as a
variety of architectural and street studies.
Among the best of these are "instantaneous,"
stop-action views such as the one shown
here. The arched top and deeply sculpted
shadows of this cabinet-format image
create a powerful sense of graphic design,
anticipating photograph styles of the early
twentieth century. Watkins's technical
skill is demonstrated by his ability to retain
the texture of the cobblestones in the strong
foreground shadow.

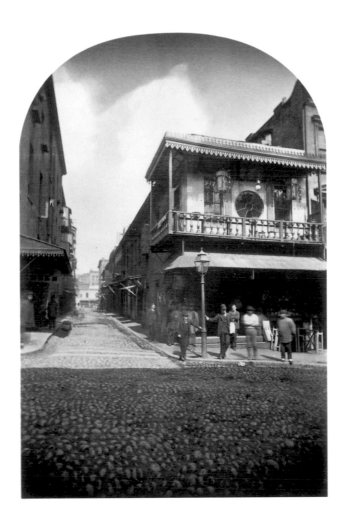

PLATE 24

Red Rock in
Echo Canyon, Utah

1873–74

Albumen print
12.5 × 16.1 cm
92.XM.81.6

Watkins and landscape painter William Keith traveled together to Utah in the winter of 1873–74. Aside from Watkins's visit to Oregon in 1867, this was one of his earliest photographic trips outside California. A Boston newspaper described their traveling technique: "They chartered two railroad cars . . . one of which contained horses, wagon, hay and feed, while the other was supplied with all the appointments requisite for domestic life." Crossing the Sierra Nevada in midwinter was an adventure; the travelers reported temperatures as low as twenty-six degrees below zero. Under these conditions it is difficult to imagine how Watkins was able to make any photographs by the wet-collodion process.

Watkins had previously cut down mammoth-plate images (see pls. 21–22); here he cropped a smaller print into an elongated oval shape that focuses the eye on the convergence of the rails and road at the center of the picture. His traveling wagon—horses still hitched—seems poised for the next dash along the endlessly beckoning path. The introduction of oval and sometimes round shapes into Watkins's oeuvre may have been due to Keith's influence.

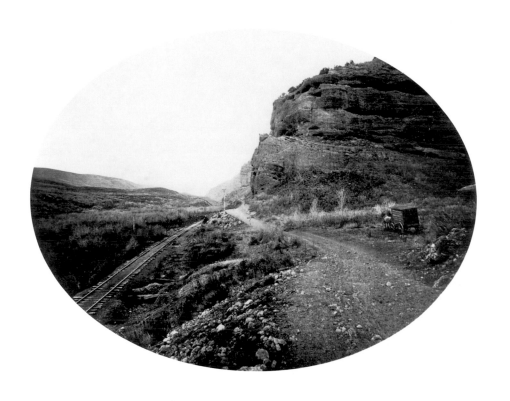

PLATE 25

View of Wharf of the Selby Lead and Silver Smelting Works, San Francisco, Cal.

Circa 1874

Albumen stereograph
7.9 × 7.7 cm
96.XC.25.5

Watkins has placed himself in this scene
as an elongated shadow in the foreground.
Elements of his camera technique can be
discerned: he is undoubtedly right-handed,
since he stands to the right of his camera
with his right hand controlling the uncap/
recap procedure used to expose the negative.
Although Watkins considered himself
an artist, he never lost his identity with the
common workingman.

The Selby Lead and Silver Smelting
Works was located in San Francisco's
North Beach area at the foot of Hyde Street.
The company manufactured lead pipe
and other plumbing goods and imported a
full line of bar and plate iron, cast steel,
sheet copper, and zinc. The brick structure
at right is probably a shot tower used in
the manufacture of ammunition.

PLATE 26

Consolidated Virginia Pan Mill, Virginia City

Circa 1875

Albumen stereograph
8.1 × 7.9 cm
96.XC.25.6

Watkins's documentation of the Comstock mining region of Nevada during the mid-1870s was both extensive and effective. Once again he was far ahead of his time in choosing camera angles that emphasized the more heroic aspects of industrialization. This photograph is a study in contrasting patterns and textures: horizontal rows of windows and vertical smokestacks, softly sculpted earth and hard-edged roof lines, black walls and white window frames.

It was while Watkins was on one of these Nevada trips that his financial part-ner, John Jay Cook, moved to foreclose on the Yosemite Art Gallery. Watkins was not a good businessman and habitually failed to concentrate on a steady source of income to tide him over between major commissions. The end result was the loss of most of his early landscape negatives to competitor Isaiah West Taber, who began publishing them as his own.

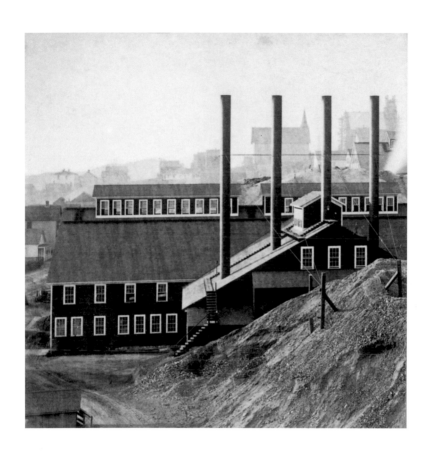

PLATE 27

"Agassiz" Column, Yosemite

1878

Albumen print
Diameter: 12.5 cm
92.XM.81.4

Watkins was largely unsettled during the two years following his bankruptcy, because most of the negatives he had created over twenty years were now someone else's property. He spent long periods in the field, including most of the summer of 1878 in Yosemite, allowing himself time to ease the pain of his losses. He replaced most of his lost negatives with new ones, calling them "Watkins' New Series of Pacific Coast Views." The Yosemite visit proved to be an artistic watershed for Watkins as well. He allowed himself enough time to reexperience the valley emotionally as well as cerebrally. He explored his surroundings with a new eye, made smaller-size images with a wide-angle lens, and experimented with masking his finished prints as a means of reinforcing his goal of carving a deeper feeling of perspective in nature. There was also another significant factor at work—he was in love. The object of his affections was the young Frances Henrietta Sneade (Watkins called her "Frankie"). She met Watkins about 1875 during a visit to San Francisco. They were married on his fiftieth birthday, November 11, 1879, in the First Presbyterian Church of San Francisco. The bride was twenty-two.

Watkins often photographed this thumblike column, which was named for the distinguished American naturalist Louis Agassiz, but none of the images are more aesthetically pleasing than this New Series example. It is a true masterwork of complexity and pictorial harmony.

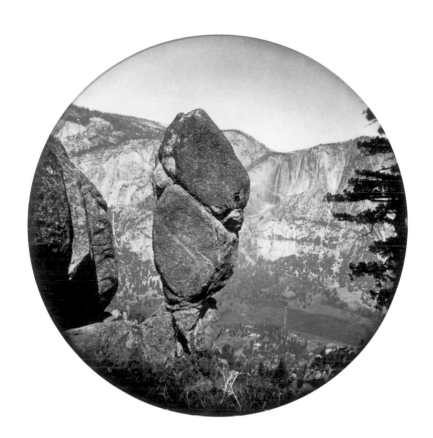

PLATE 28

Among the Treetops, Calaveras Grove

Circa 1880–90 albumen print
from a circa 1878 negative
12.9 × 8.9 cm
84.XO.250.76

This view looking straight up seems easy, and perhaps trite, in the present era of handheld miniature cameras. However, given the technology of the 1870s, it was difficult to make such a picture. Watkins presumably placed his camera directly on the ground, because tripods of the time were static platforms designed so that cameras could be pointed at the horizon. The visual concept is also very innovative for the period. Radical viewpoints such as this did not become commonplace until after about 1900.

By 1878 Watkins was considered a legendary figure in Yosemite. The valley had itself changed from a place of remoteness and isolation to one that welcomed visitors, many of whom sought Watkins out, not only to inquire about his work but also to share his wisdom. Renewed feelings of pride and craftsmanship were obvious in his latest landscape images. As Watkins wrote in a letter to a friend: "Everybody says [the new photographs] are better, softer, more artistic, etc."

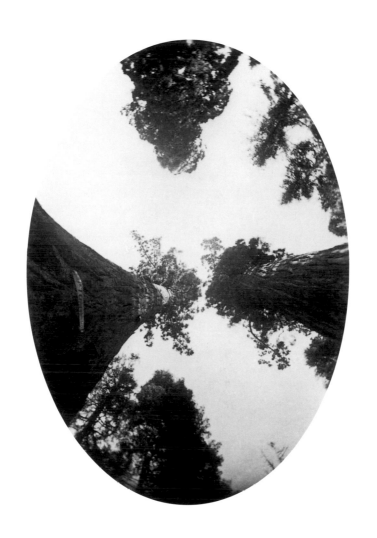

PLATE 29

Mount Round Top

1879

Albumen print
9.2 × 13 cm
88.XM.92.3

This tiny cabin is actually a U.S. Coast and Geodetic Survey workstation perched in the only secure crevice near the top of Mount Round Top (10,600 ft.), along the California/ Nevada boundary. The structure, part of an observatory facility, was only eight feet square. Everything—lumber, camp equip- ment, instruments, water, and provisions— had to be carried up the mountain by hand, since the terrain was too steep for mules. At the top there was no shelter from the glaring days and freezing nights nor was there a convenient place from which to make pictures. (The name "Round Top" was reportedly chosen as being directly contrary to the actual physical characteristics of the mountain.) From this overlook Watkins was able to obtain overviews of nearby Mount Lola and its surroundings that were as radical in their downward perspective as plate 28 is in its upward look. In what must be regarded as an understatement, expedition leader George Davidson's official report for the project noted: "Many difficulties were overcome in securing photographic views."

Although merely a detail of a much larger scene, the viewpoint selected by Watkins best shows both the cabin and its setting. The site was so cramped that a system of steps and ramps had to be built for access. The roof of the structure, the only flat surface available for storage, also served as a walkway from one side of the crevice to the other. A sense of scale is provided by the cook, whose white hat and apron punctuate the cabin's shadow.

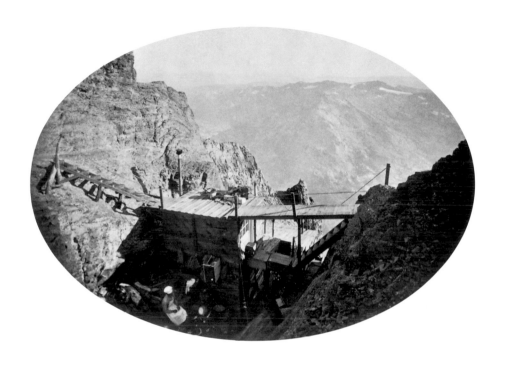

PLATE 30

The Plaza, Los Angeles

Circa 1880

Albumen stereograph
7.9 × 8 cm
96.XC.25.7

Watkins made his way to Southern California in 1877 and again in 1880 by way of the Southern Pacific Railroad. The second trip took him south and east as far as Tombstone, Arizona, and then back to Los Angeles. He used his traveling wagon to explore the area from San Diego northward along the Pacific Coast. As a result of this prolonged journey, Watkins was able to add hundreds of new negatives to his New Series collections.

The Los Angeles church shown in this picture (Our Lady the Queen of the Angels, built 1818–22) still stands today but has undergone extensive changes. The plaza, formerly the town square, was given its circular form in 1871 and landscaped in 1875. To the left of the church is the adobe home of Andrés Pico; behind it is the Cape House Restaurant, with its distinctive triangular pediment. In the background is Fort Moore Hill, which, with its neighbor Bunker Hill, "rose like a spine in the center of old Los Angeles" (Arnold Hylen, *Bunker Hill: A Los Angeles Landmark*).

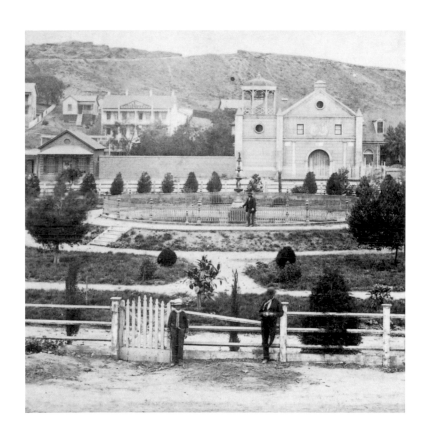

PLATE 31

Beach and Bathing
House at Santa Monica

1880

Albumen print
11.1 × 17.8 cm
94.XM.30.2

On June 26, 1880, Watkins wrote a less-than-happy letter to his wife from Santa Monica, California: "I am down here by the illimitable and ever restless sea, and it does nothing but sigh and moan and *blow, blow, blow*. . . . I did not put on my overcoat and nearly froze." This photograph of the beach was taken from a pier extending out into the Pacific.

Watkins's boudoir-style pictures were an adaptation of the more traditional 5-by-8-inch landscape panels commonly used by photographers during the 1880s and 1890s. However, instead of having the image occupy the entire print area, Watkins masked the view to include wide print margins, frequently with a domed top. Letterpress captions were imprinted on the mounts (tourists could purchase these views mounted or unmounted). Watkins's most interesting innovation, however, was a specially designed stereoscopic camera that took a large glass plate measuring 5½ × 14 inches. He could thus make the equivalent of two negatives (a stereo pair) at each exposure. From each end of the plate he produced prints that were approximately 5 × 7 inches. By using the proper printing masks, he could create stereographs and/or individual cabinet and boudoir prints, all from the same original negative. As far as is known, Watkins was the only Western landscape photographer to employ this technique.

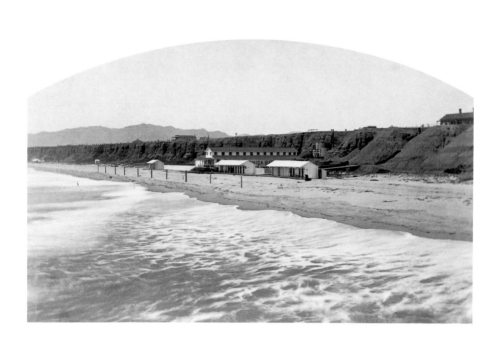

PLATE 32

Ready for Irrigation

1880

Albumen stereograph
7.9 × 7.9 cm
84.XC.979.7338

Part of Watkins's goal in visiting Southern
California was to produce photographs
that would demonstrate the enormous agri-
cultural potential of the region and rein-
force the idea that the area was a farmer's
paradise where everything grew bigger
and faster than anywhere else. As always,
these were not ordinary pictures. In this
image of Sunny Slope from San Gabriel in
Los Angeles County, the marching lines
of trees, together with the strong, contrast-
ing shadows between them, create a visual
masterpiece, whether viewed here as a
two-dimensional object or in three dimen-
sions in a stereoscope.

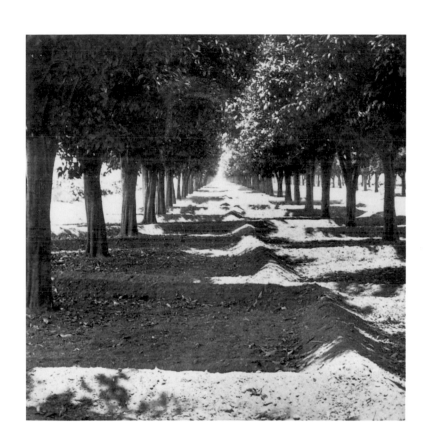

PLATE 33

**Star Oil Works,
San Fernando District,
S.P.R.R.**

1880

Albumen stereograph
8.1 × 7.8 cm
96.XC.25.8

The discovery of oil in the San Fernando
Valley dates from the 1850s, but large-scale
exploitation did not occur until the 1890s.
While on his 1880 trip along the route of
the Southern Pacific Railroad, Watkins made
some of the very earliest pictures of the
fledgling petroleum industry in Southern
California. Because of his work in the
mining industry in Nevada, he was very
experienced at photographing the machin-
ery and trappings of industrial activity.

 This particular image of a California
Star Oil Works Company well is oddly
portraitlike inasmuch as the derrick stands
aloof from a hillside backdrop patterned
with scrub vegetation. This feeling is further
reinforced through the use of a long-focus
lens, which brings the tower closer to the
viewer and compresses the space between
foreground and background.

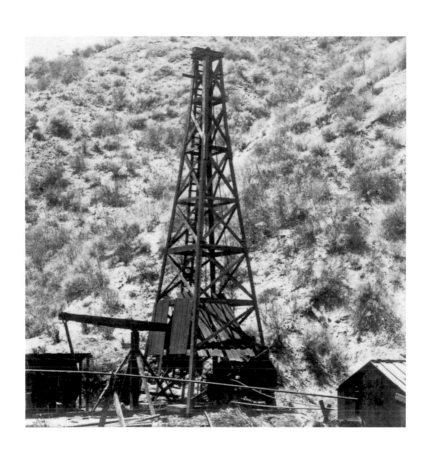

PLATE 34

La Jolla, Pacific Coast, near San Diego

1880

Albumen stereograph
8 × 7.9 cm
96.XC.25.9

This photograph, made within a few days or weeks of plate 33, shows how Watkins could adapt himself to the needs of very different subjects. Whereas the Star Oil derrick stands as an industrial document, this image is intimate and romantic. Greatly enamored with the wind-sculpted rocks along the Pacific shoreline, Watkins made many views of interesting geologic shapes. He also liked the interplay of the waves between the rocks and in the tidepools. Unlike plate 37, where the quick exposure freezes the breaker, here a prolonged exposure allows the water to move, creating a quieter, more mysterious effect and making the rock formations seem softer than they really are.

PLATE 35

Cereus Giganteus
in Blossom, Arizona
1880

Albumen stereograph
7.9 × 7.9 cm
84.XC.873.4607

Only a little of Watkins's personal correspondence survives today, including a series of letters he wrote to his wife during his extended trip to Southern California and Arizona in 1880. In Arizona he grumbled a great deal about the hot climate and the difficulty of working with his chemicals. A letter dated May 13 clearly expresses his overall frustration: "This infernal climate gives me the best possible excuse to get mad for not a stroke of work have I done since I wrote you last. It has been blowing sand night and day. . . . [also] the Colorado River is rising fast. The only difference between the land and the water is that one is dry sand and the other wet & looks like rolling mud."

Despite his remarks, Watkins found many elements of beauty in the desert. This image, one of a continuing series on the flowering cacti of Arizona, is related to earlier still-life arrangements, such as plate 10.

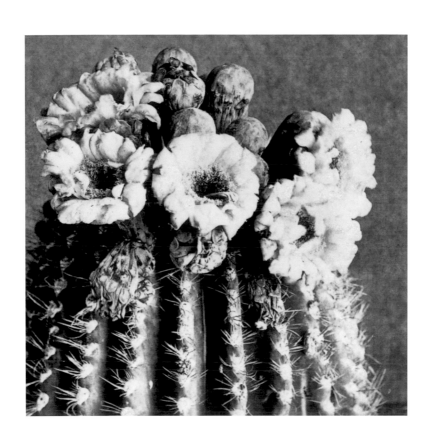

PLATE 36

**Interior of Pavilion,
Built on Stump
of a Tree, Mammoth
Tree Grove,
Calaveras Co., Cal.**

Circa 1882

Albumen print
12.9 × 8.9 cm
84.XO.250.79

This striking photograph is both curious
and mysterious. The play of light and
shadow reveals a ghostly self-portrait of
Watkins in the foreground and the figure of
a seated woman in the background. She
is Sallie Dutcher, a sales agent for Watkins
and Frankie's archnemesis. There is every
indication of a romantic attraction—if
not an outright liaison—between Watkins
and Miss Dutcher, known as the "tall
woman." Watkins was unique for his time
in incorporating traces of his personal life
in his pictures in such imaginative ways.

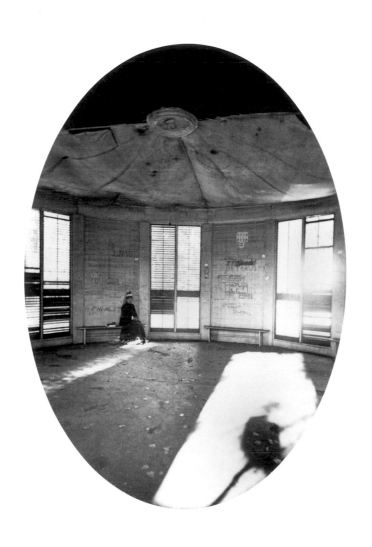

PLATE 37

Surf View on the Cliff Road, Santa Cruz

Circa 1883

Albumen print
11 × 17.5 cm
88.XB.97.11

In January 1883 Watkins visited California's Monterey/Carmel region, where he made numerous negatives of the Hotel Del Monte and the local coastline. He also photographed ocean views farther north near Santa Cruz, including this dramatic and thunderous seascape.

Watkins prided himself on his ability to produce stop-action images, and in an era of "slow" emulsions and shutterless cameras, this was no small feat. His technical innovations included photographing only under bright, midday conditions, using chemical accelerators to boost his film's sensitivity to light, and "forcing" the negative to develop through the use of special processing formulas. In some cases negatives were chemically "intensified" after development. The actual exposure was accomplished by an exceedingly quick uncap/recap of the lens or by moving a dark slide in front of the lens. In this manner exposures as short as $1/25$ of a second were possible.

The most important element of this scene is its timing—Watkins captured the climax of the wave's explosive power. Even today, when shutters operating at $1/1000$ of a second are commonplace, timing for peak action is difficult and critical to the artistic success of an image. Watkins further enhanced the qualities of this picture by choosing a slightly elevated camera position so that the waves are profiled against the dark headlands.

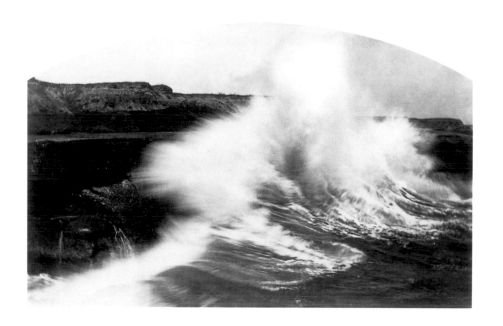

PLATE 38

Rooster Rock,
Columbia River

1883

Albumen print
12.1 × 20.5 cm
92.XM.99.8

Watkins's son, Collis, was born on October 4, 1883, yet by November 18 an observer wrote of seeing Watkins at work near The Dalles (on the Columbia River in Oregon): "Watkins the photographer who took my Yosemite views is here. He has a sleeping car to himself and is put onto a siding wherever he wishes."

The artist's son had been named after Collis P. Huntington, whose connections with the Southern Pacific Railroad had enabled Watkins to haul his traveling wagon over company lines. This picture clearly shows the unique travel arrangement in practice. The signage on the wagon reads: "Watkins Yosemite Gallery, 427 Montgomery St., San Francisco" (see detail on p. 6). Below that is the name of William H. Lawrence, the businessman who helped finance Watkins following the loss of his original Yosemite Art Gallery.

Watkins journeyed to Oregon, Idaho, and Montana (including Yellowstone) in 1884. That year he also began to use factory-prepared dry-plate negatives for certain types of projects, including the nearly one thousand images he made of Kern County, California, agriculture in 1888, just one year shy of his sixtieth birthday. By nature and because of financial circumstances, Watkins was unable to slow the pace of his work—work that never seemed to bring him enough money or enough respect.

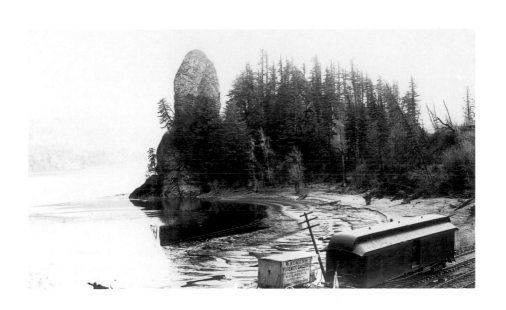

PLATE 39

Palace Hotel, Montgomery Street, San Francisco

Circa 1885

Albumen print
19.1 × 11.7 cm
92.XM.99.1

This cosmopolitan scene could easily
be that of a European capital. By the 1880s
San Francisco had grown from its frontier
origins to become the most sophisticated city
on the West Coast. Shown here are cobble-
stone streets, streetcar tracks, a handsome
clock, and, at the end of the thorough-
fare, the fabled Palace Hotel, the finest in
town. Watkins had had his ill-fated Yosemite
Art Gallery at 22–26 Montgomery Street,
just down the block on the left. The grow-
ing success of San Francisco was not
the same as success for Watkins, who was
fast becoming a pauper in a city that was
becoming increasingly golden.

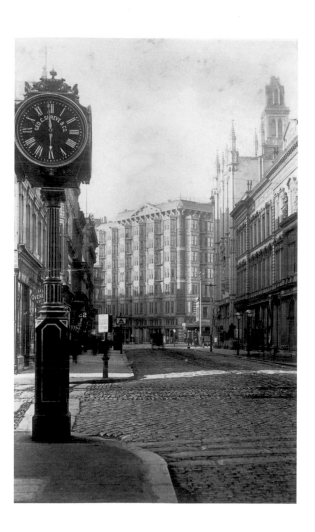

PLATE 40

Portrait of
George Davidson

Circa 1887

Albumen print
20.3 × 16.5 cm
88.XM.92.85

George Davidson was a strong Watkins supporter who often provided employment in connection with the U.S. Coast and Geodetic Survey. This employment ranged from full-scale field work, such as the trip to record the Mount Round Top project in 1879 (see pl. 29), to the photographic reproduction of maps and documents for the survey. There are numerous surviving portraits of Davidson, taken by various studio photographers, almost all of which show the scientist with his head turned in a three-quarter profile. None, however, approach the sheer majestic power—the monumental likeness of character—of this full-profile study by Watkins.

Davidson and Watkins were of similar age, yet as Watkins composed this picture in his camera, he could not have helped but notice the disparity of their circumstances. Davidson was completely secure in his career. Even when he was no longer able to perform field work, he was appointed honorary professor of geodesy and astronomy at the University of California. Watkins, by contrast, was fast nearing the end of his working life.

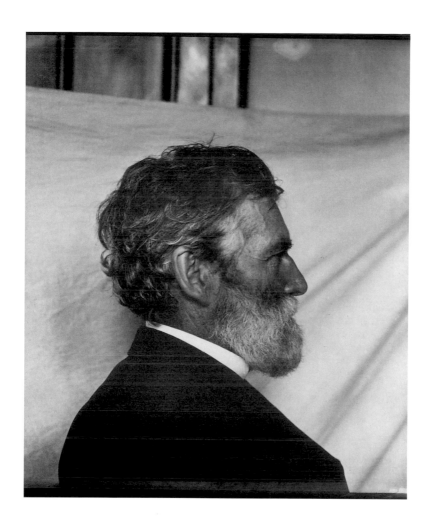

PLATE 41

Solar Eclipse

January 1, 1889

Albumen print
16.5 × 21.6 cm
88.XM.92.83

This masterful photograph appears to be the only surviving print from the dry-plate negative. Little is known about the image other than the fact that it was taken from a site on the Santa Lucia Range near Big Sur, California.

In 1890 Watkins was in Montana, photographing underground in the copper mines. He was already suffering from diminished eyesight and was plagued by arthritis: "Yesterday I was taken with one of my vertigo fits. . . . I hope it will not be a bad attack, if it should the Lord save us." He performed other commercial work into the early 1890s but was unable to cover his mounting debts. At one point the entire family lived in a railroad boxcar for eighteen months.

On April 18, 1906, the San Francisco earthquake and fire totally destroyed Watkins's prints, negatives, records, and a lifetime of closely held mementos and memories. As a consequence, the archaeology of his life remains difficult, fragmentary, and at times tentative. Following the earthquake, Watkins (now nearly blind) and his family retired to a small ranch (given to them by Collis P. Huntington) near Capay, California. In 1909 he was declared incompetent and his daughter, Julia, became his guardian. In 1910 he was committed to the Napa State Hospital for the Insane, at Imola, where he died on June 23, 1916, at the age of eighty-seven.

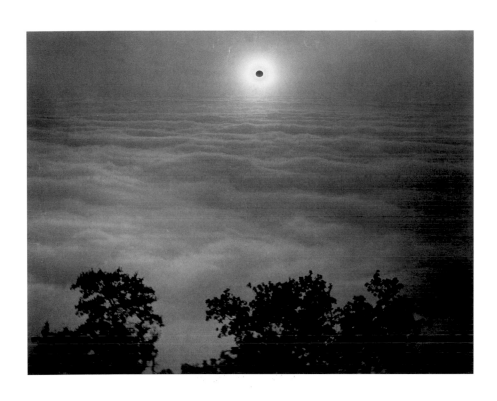

Pietro Mezzars. *Cameo of Carleton Watkins,*
circa 1868–69.
Photograph courtesy of Yosemite National Park.

Looking West:
The Photographs of Carleton Watkins

David Featherstone: Before we begin our discussion of Carleton Watkins's photographs, it might be appropriate to ask Amy Rule to give a brief chronology of his early life, since she is the editor of the most recent publication on him, *Carleton Watkins: Selected Texts and Bibliography.*

Amy Rule: We know a few things about Watkins's early life that are helpful in studying his work, but there's an awful lot we don't know and may never know. Serious scholarly attention has been focused on Watkins for only about twenty years. In recovering his past, we should guard against inferences based on lack of information and inflating what information we have in order to fill in the blanks.

Watkins was born on November 11, 1829, in Oneonta, on the Susquehanna River in New York. Little is known of his life before he, like so many others from New York, immigrated to California after gold was discovered in 1848. What is reliably known has been gleaned from a few public records, some secondary sources, and an interview conducted with Watkins in 1905. Although much of this interview can be attributed to his desire to recount happy boyhood days, the transcript, now at the Upper Susquehanna Historical Society, is important. Watkins talks about his enjoyment of singing and participating in public events and even describes being in a parade that included a float with a live raccoon and a log cabin. These indicators are consistent with the lightheartedness and love of human interaction seen in his later life, especially in letters to his wife.

It is believed that Watkins arrived in California in 1851. His daughter, Julia, stated in interviews conducted late in her life that he talked about coming overland, but some documentation indicates that he may, in fact, have come by the quicker sea route. When he got to California, instead of heading for the gold fields, he did what many of us would have done—he made contact with other New York migrants. Thanks to the influence of his friend Collis P. Huntington, he got a job in Sacramento; then for a year or so he knocked around working as a carpenter and a bookstore clerk. His life at this point seems like that of a typical young man trying to find his way in a strange land.

In 1854 Watkins began to work in Robert Vance's daguerreian gallery, possibly in Marysville, California. He evidently didn't seek out photography, but rather recognized an opportunity and began learning the craft. By 1856 he was employed in the San Jose studio of James M. Ford, south of San Francisco. By this time he was proficient in daguerreotypes, salt prints, and probably ambrotypes, although we have very few clearly attributable examples of this early work. We know from contemporary advertisements in magazines and newspapers that he made portraits, indicating at this time that he was not setting himself above the life of a commercial studio photographer.

By 1858, however, Watkins was finding ways to use the camera outside the confines of a studio. He was commissioned to photograph the Guadalupe Quicksilver Mine to produce evidence admitted in a trial and was making pictures in San Francisco, where he was living. He also began traveling outside the urban environment, photographing in the Mariposa area near Yosemite. By the end of the 1850s Watkins's business was thriving enough that he could afford to share the rent for a studio on San Francisco's prosperous Montgomery Street.

DF: The first picture we're going to look at (p. 93) comes from this period of Watkins's early work as a photographer, when he was in the San Jose area, but it has not been clearly established that this was made by him. It is a fragment of an ambrotype, which is a positive image made on glass. Peter, you've established some evidence that may attribute this to Watkins.

Peter Palmquist: Basically, it involves the fact that Watkins was in San Jose and connected with James M. Ford. If we are looking at this as possibly the earliest

Attributed to Carleton Watkins. *Rancho of Augustin Alviso,*
"Potrero de los Cerritos," near Centerville, 1856.
Ambrotype fragment, 7 × 20 cm. 96.XT.64. Gift of Peter E. Palmquist.

artifact that can be attributed to Watkins, the connection has to be tenuous, but there is a succession of evidence that suggests it's highly likely. If this is not by Watkins, it is probably by Ford, but the latter was away for long periods of time. One of the competing photographers in San Jose talked about the success that Ford had at the state fair. He referred specifically to the quality of work of a man Ford employed on and off. This infuriated the other gallery owners, who said, "This isn't your regular employee." I believe this is a reference to Watkins.

Weston Naef: This picture has been identified as the Augustin Alviso ranch, which was in the southeast part of the Bay Area, near Newark. Its association with Watkins is based on a series of circumstantial associations with a handful of other surviving photographs. These contain some common threads that are so slender that it's hard to imagine we could begin to identify this particular picture with any known maker. Stranger things have happened in the history of art, however. For example, some of the greatest vase paintings of ancient Greece are attributed to known makers on the basis of tiny fragments, where the visual sensibility of a maker is so clearly evident that a consensus of opinion comes to be formed that a fragment can stand for the entire work of a maker.

PP: This came from the Alviso family. It has always been known in the family for what it is and remains the only known image of that particular site. It is a full plate, and full-plate ambrotypes are rather uncommon.

AR: Are there some ambrotypes by Ford that have been identified?

PP: There are some that are attributed to him, but nothing has been demonstrated absolutely. None are of an outdoor nature.

Tom Fels: If you try to picture this as a whole plate, while it's certainly typical of its time, it has some things that we might agree are characteristic of Watkins. It has a kind of clarity and stateliness in the presence of the building, for example. I couldn't say that it's Watkins, but that's not a bad place to start.

WN: To go one step further with what Tom is saying, what makes this so promising is that we are seeing evidence of a major event. If you look along the balcony, you'll notice that a number of people are posed there. There's a wagon in the foreground. Perhaps most important of all is the arrangement of the three horses: one looking forward, one looking to the right, and one looking to the left. We're seeing here that someone had enough charisma to orchestrate a courtyard full of people and animals into a setting of his wishes. We know from other work by Watkins, particularly his landscapes around the Bay Area, that he was a master at placing figures in landscapes.

When I first saw this fragment—and I tend to be pretty skeptical about such things since everybody wants to read something into the unknown—I felt that it was really uncanny. It somehow had the mark of mastery, and there were not very many people working in photography in the southern Bay Area who had this kind of mastery. It could have been Ford, but we assume that he was a specialist at photographing indoors. Watkins had begun to establish his own identity as someone who was particularly gifted at working with situations in flux.

David Robertson: If you look at the way the trees are orchestrated against the background rocks in the 1861 photograph *River View, Cathedral Rocks* (pl. 5), which we will discuss later, you come to the conclusion that Watkins chose that particular view very carefully in order to produce a syncopation of rocks and trees. In this photograph, if you look at the arrangement of the horses and the people and the

wagon and the building, you see the very same care to spread things out so they establish a rhythmic counterpoint.

WN: Peter, can you talk a little bit more about the role of the wagon? It has appeared in other very early and exceedingly rare photographs and therefore establishes a common thread that cannot be ignored.

PP: There are six images we are aware of that were made in this general area, and in four of them this same wagon appears. Of the six images, Watkins subsequently copied or manipulated four of them, and they appear in his work thereafter. Also, there are connections between Watkins and other photographs. One in particular is the view of Sutter's Mill that we are sure was taken by Vance, but which Watkins copied and used for many years.

WN: Let's pursue that for a second. How do you know for sure that the Sutter's Mill picture was taken by Vance rather than by one of his assistants?

PP: Well, we have not seen the original, obviously, but it's datable to the period just after that of the three hundred daguerreotypes Vance made showing scenes of the gold rush.

WN: Vance made a reputation as an outdoor photographer and was the creator of this famous set of three hundred daguerreotypes, which is a monumental achievement in the history of American photography that no one has seen because the work was all lost. But is it really possible that Vance himself could have made all three hundred of those pictures? Didn't he have to have an assistant?

This leads to the question of who Watkins's true teacher was. How did he acquire the seeds of his dedication to working outside the studio? Ford can perhaps be eliminated, because he was chiefly a portrait photographer. One hypothesis could be that Watkins worked for Vance during his gold rush project, that he actually created some of the outdoor views that were issued under Vance's name. Studio owners normally hired what they called operators, and it would seem that Watkins could have learned the craft of outdoor photography during the time he was working for Vance. The reason he would have copied Vance and other photographs is because those pictures were one of a kind—they were made by the ambrotype or daguerreotype process, which results in a single, unique original.

This suggests an aspect of Watkins's personality. If you have an ego of the kind most really great artists have, there is a desire to preserve what you have created, even if you can't actually own it yourself.

PP: I believe Watkins admired Vance's ability to promote himself and to be visible in the marketplace, but I think of Watkins as being pretty far down the totem pole at the time this ambrotype was made. At some point he decided to work with a large format and ultimately to create paper-based prints, which could be reproduced without copying. The 1859 Mariposa images are salt prints, as is the Guadalupe print.

WN: The miracle is that sometime between 1856, when this fragmentary piece that could be the earliest surviving work by Watkins was made, and 1861, when he decided to travel to Yosemite to make his monumental series there, he decided to commit himself to the profession of photography. The problem is we don't know very much about what happened in that five-year period.

PP: One question that arises is that if Watkins was trying to work large, which was more expensive, what were the rewards? One was that he got to testify in court with his Guadalupe image. This is the case of *U.S. v. Fossat* from 1858. The contention was over the boundaries submitted for the Guadalupe Quicksilver Mine. The Watkins photograph, actually two photographs mounted side-by-side that are now housed in the National Archives, was used to show the relationship of a certain landmark to the landscape. When he was asked to talk about the fact that he took the photograph, Watkins said: "It's a view of the country looking south. It is accurate. The buildings are the buildings of the Guadalupe Mining Company." I believe this is the earliest landscape image to be introduced into the Northern District Courts of California.

WN: In the transcript of this trial, then, the reply to that question is the earliest first-hand remark that survives from Watkins.

PP: Yes. He also told the court, "I am twenty-nine years old, reside in San Francisco, California, and am a photographicist."

WN: When he was asked whether he had selected the point from which the view was made, he essentially said yes, he selected it, he chose the spot that would give the best view. So this first verbal statement that we have from Watkins relates to the aesthetics of his art. One of the themes that will be pursued here is Watkins's ability, throughout his career, to choose the best view. One of the reasons that this ambrotype fragment strikes me so compellingly as possibly being the work of Watkins is because of the intelligence by which he has managed to create the best view of a very amorphous place.

Could we return to the word *photographicist* and ask why Watkins did not describe himself as a photographer?

PP: I think the issue is not the difference between a photographer and a photographicist as much as that he didn't call himself an ambrotypist, or a daguerreotypist, or an artist. He called himself a photographicist, I think, in an effort to differentiate between himself and others and to proclaim that he was now entering into working with paper. I think that's a very important crossroads.

WN: *Photographicist*, which seems like an invented word, suggests an illustrator. A photographer somehow seems to be more limited in scope, whereas if someone is a photographicist, it means that you are somehow more expert. This goes back to the question of what sort of ego is driving this person. I am fascinated by the choice of the word, because it seems to be a self-enhancement: "I am not a mere photographer. I do something that is beyond mere photography."

DR: One might also conclude the opposite. In English, *-ist* words often describe technicians. In the context of court testimony, Watkins may have been trying to present himself not as a photographer, to which might be attached some notions of artistry or interpretation, but as a technician who is able to provide a very accurate rendering of the relationship of things in the landscape.

TF: In either case, Watkins apparently submitted an outstanding landscape photograph as a court document. Anyone who has looked at documentary photographs knows that many of them are relatively unexceptional. In a way, Watkins was educating his audience by using that word and by showing what photography can do.

DF: One format in which Watkins clearly showed what photography could do was the stereograph. He's perhaps known more to the general public for the mammoth sixteen-by-twenty-inch prints made from eighteen-by-twenty-one-inch glass negatives, but at the same time he was also doing photographs in a number of smaller sizes. In the stereograph *Yo Semite Falls. 2630 ft* (pl. 3), which is from Watkins's first trip to Yosemite Valley in the summer of 1861, each half of the image is approximately three by three inches. This is much smaller than the mammoth glass-plate negatives, yet Watkins brings the same sense of conscious design to this picture that he does to the larger ones.

WN: I think it's important to draw attention to how some elements of this stereograph suggest the nature of Watkins's sense of identity. First of all, this is a photograph on glass that can only be viewed when held up to the light. He signed his own name on the paper mask he cut to give the edges some definition and assigned the image a very succinct title.

These are two significant elements—he put his name on it, and he felt that, as a picture, it must have a title. He chose his viewpoint so that not only is the little structure in the very near foreground dappled in sunlight, but more importantly, the waterfall comes so perfectly between the extreme branches of the two trees that are set apart. He's literally shown that his discerning eye can place this key element within all of the givens that he has to work with. He has to have the building in the foreground and the trees framing the waterfall, yet the trees can't intrude upon the falls.

PP: I would add another technical feature. When he composed this view, it was upside down in his ground glass, so he was looking at it inverted. Later, when he published stereoscopic views on paper, he was able to shift the image laterally or up and down when he cut out the frames for placement on the card.

DR: A photograph like this is an extraordinarily good example of how style comes out of equipment. Style is not simply a function of one's vision, it's also a function of the equipment that one deals with. In this case it's a stereograph, so he needs foreground elements in the picture. This leads him, then, to view the falls through some sort of foreground.

One could draw two conclusions at this point. The first is that he was after some sort of picturesque style. The second is that he had no such notion in mind; he simply needed a foreground. This meant that the major element in the picture, Yosemite Falls, would be seen as distant and framed. I would conclude, looking at this photograph, that Watkins was able to realize the demands of the equipment and still produce a photograph that expressed his own vision.

TF: I consider this a difficult image, because the background is a very clear landscape shot, and in the foreground is what appears to be a disjunction between the cabin and the landscape that I don't quite understand. Why place this cabin here unless it is to be considered picturesque? I'm not sure it quite qualifies as that, but I think it's characteristic of a nineteenth-century problem in looking at photography and Watkins. To understand nineteenth-century photography and the way Watkins works, you need to have a way of understanding this disjunction.

AR: There is a theme here that he comes back to again and again: he is choosing very carefully to find a small structure and place it in the view so that there are large trees around it. It's a very serene, comforting view. Someone on the East Coast could look at this and say, "Ah, I could stay in that little cabin and put my jacket over the log there and dry it in the sunshine." But he doesn't show the trash heap off to the right side; he doesn't show anything too rough and unpleasant. It's very comforting to think that you could go there and see that spectacular, sublime view and yet be comfortable at the same time.

When you look at this through a stereoscope and have the chance to appreciate the illusion of three dimensions, the shingles on the side of the cabin are so vivid that they give you splinters in your nose. This might have been one of the glass views that Watkins sent east in 1862. In "On the Doings of the Sunbeam," Oliver Wendell Holmes's famous essay of the following year, he draws attention to the fact that viewing a stereograph is not just an exercise for the eye but also one for the mind. He says, "The mind feels its way into the very depths of the picture," which is a lovely way of putting it.

WN: Watkins's Yosemite views became famous all over America and the world for showing an Edenic paradise. If I'm not mistaken, the balance of the one hundred

stereographs of Yosemite are totally without figuration. I'm using the word *figuration* to refer to elements like the little cabin and, to a lesser degree, the trees. The trees in the left foreground are classic figurative elements. In the rest of his Yosemite stereographs the view is much more distant. The element of figuration becomes much less significant because the photographs are so panoramic.

I see this as an important picture; I'm arguing that it could be the first, grounding view. It's the statement of "Yes, there is human habitation in Yosemite; it is not an Edenic paradise; this is where I stayed."

DR: There's always a danger that we read our own notions of what human presence in a landscape means. There is a dictum sometimes broadcast by historians that a document is a primary source of the period in which it's done and a secondary source for a period about which it's done. If we imagine our colloquium as a document, then we need to remind ourselves continually that, from the point of view of anybody in the future, what we say today is a primary document for us and a secondary document for understanding Watkins.

As a case in point, at the latter end of the twentieth century we are so very aware of how landscape can be spoiled that we may see the presence of human things in a landscape as a problem. If you go back, however, to the paintings that show an idyllic American landscape, including the Hudson River school and even painters who came to the West, you can argue that they felt no such tension. The presence of human elements in the landscape simply contributed to it as Eden, they did not detract from it.

TF: The foreground and background of this stereograph almost make it two different pictures. In the background is the classic landscape; in the foreground you almost have the beginning of Watkins's very sophisticated architectural work done around San Francisco Bay and in many other places. The building is in three dimensions and has its beautiful, mottled shadows, but I would contend that the foreground is almost modernist and the background is a typical kind of nineteenth-century landscape. I have trouble putting them together, but it may be a problem of our time as opposed to his.

AR: What David was saying reminds me of something that the historian Martha Sandweiss has said about Watkins. To paraphrase her, she said that Watkins was an

adventurer in his own land, whereas when Timothy O'Sullivan photographed in the West, he was a traveler in an exotic land. She feels that with O'Sullivan there is a sense of awe and danger and suspense and drama, which of course is why we love his work, but with Watkins, and perhaps particularly in this picture, he is in his own element.

We should remember that 1861 was the opening year of the Civil War. It is important to note that, in contrast to other great American landscape photographers like George Barnard, William Bell, Alexander Gardner, John K. Hillers, O'Sullivan, and Andrew J. Russell, circumstances kept Watkins uninvolved in the war. California's participation in the conflict was minimal due to its decade of isolation since statehood.

DR: Watkins's situation helps explain how the photographs were received back east too. When these images arrived on the East Coast, presumably in 1863, the people were right in the middle of the war. They would have seen Watkins's Yosemite photographs in a very distinct context, as representing an ideal that definitely was not present in their own everyday reality.

DF: Let's move on to the next work, which again is a stereograph on glass from 1861. It shows the Three Brothers reflected in a body of water and is entitled *"Inverted in the Tide Stand the Grey Rocks"* (pl. 4).

When I first looked at this through the stereoscope, at the point when my vision adapted to the depth of the scene, I experienced a distinct feeling of vertigo. In the last image, the foreground plane of the house and the trees was vertical, but in this photograph the foreground plane runs from the land right in front of the camera to the bank on the other side of the water. When the three-dimensional perspective kicks in, it doesn't move back in space, it goes straight down.

WN: Once again, Watkins has signed this on the paper mask and provided a title. Amy has identified the source of this poetic inscription as Longfellow's "An April Day."

DR: I see elements in some of Watkins's 1861 work that seem to be in the romantic, picturesque tradition. A hallmark of that tradition is the use of poetry to entitle photographs. I would say that Watkins is flirting with that tradition; he is drawn

to it but has not quite decided whether he wants to employ it or not. I don't know of any other case where he uses poetry. He simply entitles the photographs to describe the scene.

PP: By this time, Watkins had made friends in San Francisco social circles who were more learned and more apt to discuss these things. He became acquainted with Thomas Starr King, the Unitarian minister, and interacted socially with people at the Frémonts' house. There were tête-à-têtes about literature and who knows what else. He would carry this sensibility with him when he was in Yosemite; around the campfire there might have been discussions about the literary parallels of this sublime scene.

WN: Perhaps a way to approach this, since it is such an exception for Watkins to have chosen a verse of poetry as his title, is to ask why he focused on this particular text. Of course, the most obvious answer is that it relates to the subject of the picture, which is one of the great monuments of Yosemite, the Three Brothers.

We're dealing here with a second piece of aesthetic writing, after the quotations from the 1858 court case. I would like to focus on the word *inverted,* because it is so important to the process of photography. Peter has already mentioned that Watkins saw these images upside down, as do all photographers who work with a view camera. What we are seeing, however, is the inverted subject from nature. The three rocks are normally seen against the sky, but we are seeing them reflected in a still body of water. They are therefore inverted to us and natural to the way Watkins would have seen them in the ground glass. The total appropriateness of this text to the subject tells us that he was sensitive both to verbal communication and to the difference between verbal and visual communication.

Through the choice of this text, we have yet another window on what Watkins's mind must have been like. He selects the word *inverted* as if to say, "Aha! That's my life! My life is about seeing the world inverted and somehow presenting it to the public in the correct way." This use of the camera to reverse or invert natural associations seems to be a central theme of his photography and is quite an intellectual one.

AR: This is one of the rare instances where we have a contemporary reaction to a specific image. Watkins sent this work along with other glass stereographs to Oliver

Wendell Holmes in 1862. Writing in the *Atlantic Monthly* in 1863, Holmes specifically described this picture, and it's interesting that he makes no reference to the caption. He talks about several other views and then says: "And three conical hilltops of Yosemite, taken not as they soar into the atmosphere, but as they are reflected in the calm waters below—these and others are shown, clear, yet soft, vigorous in the foreground, delicately distinct in the distance, in a perfection of art which compares with the finest European work."

WN: Watkins started making glass stereographs in 1861 or earlier. They were the perfect vehicle for him, because the transparency that he saw in nature, the transparency of the water necessary to create the vertigo that David mentioned earlier, was really best done in the stereographs—but they had a tragic flaw. With a glass stereograph he had to show the entire piece. In order to frame it, he had to cut a paper mask, and this was highly labor-intensive and impractical. Also, he had no control whatsoever over the center line, which could be very messy.

These glass stereographs were produced in a limited number in a very compressed time frame. There is a direct relationship between the making of the picture and the use of the quote. It may be that somebody looked at the stereograph and said, "Carleton, there's this wonderful text," and so he began adding it to a few stereographs.

TF: I think the fact of the inversion and the general view from this site, in combination with the title, is an indication of an interest in the picturesque, which brings up the intended audience. Who would this have been made for? That's a key issue in discussing photography. One would assume that a picture of the Three Brothers would be normal, so the public would be interested in this inversion as a kind of oddity. This image would also be a technical tour de force in that the water has to be very calm. He was probably proud of it for that reason too.

DR: We also have to keep in mind that the audience was not the general public at this point, but very selected people. It's clear by the letters between William Brewer and J. D. Whitney in 1862 that this was simply not a public thing. There was no sign in a window that said, "Come and see my views from Yosemite." Watkins was making these photographs, and people were being invited to come to see him and share

them. Sets of photographs were creeping out to a select audience, but this was hardly, as yet, a public phenomenon.

DF: One of the special things this select audience was treated to was Watkins's mammoth prints. Earlier, David mentioned this 1861 picture, *River View, Cathedral Rocks* (pl. 5). The upper corners are rounded into a dome shape, which is something seen frequently in photographs from this era.

PP: It also occurs in certain lithographs from the period. Watkins seems to have done this at least into 1864, but by 1865 the prints have square corners. It's definitely a convention he used early on.

DR: Do you have a sense, Peter, that he's using the rounded corners because it is a convention of the day, or have the corners been rounded off to eliminate distortion of the subject from the inadequacy of the lens to cover the entire plate?

PP: The argument can be made both ways, and simultaneously. If he is using a rising and falling front, which we believe he did since he was able to maintain the vertical so successfully in most views, then the circle of illumination would fall off in the corners, and he had the choice of masking them, leaving them, or trimming them. There's been valid conjecture for both style and utility; I think early on both were probably a factor.

DR: This photograph illustrates very well how Watkins found the right spot for his camera. One can imagine him walking deliberately back and forth to see how the trees would relate to the background and then choosing a spot where the V between little Cathedral Rock and big Cathedral Rock is seen through the trees and where one tree goes right up into the shadow between the two rocks.

WN: The accomplishment of what we're seeing in these mammoth-plate photographs should be considered. You couldn't buy a mammoth-plate camera as a manufactured item at this point. Watkins had his large camera made for him, so we're dealing with an element of intentionality. Primitive enlarging methods existed, but the results were considered so unsatisfactory that they were not used for display purposes. If the photographer wanted a picture that would hold the wall like a painting, that was sixteen by twenty inches in size and could be hung in a

dining room for decoration, he had to use a camera that size. Watkins deserves credit for realizing that his subject was so large in scope and his vision so grand that he should have a camera made and transport it to Yosemite for the purpose of creating these scenes.

PP: Watkins was the first to make mammoth plates in Yosemite. Charles Weed was there earlier, but his pictures were what we call imperial size, about ten by thirteen inches. There is also a difference in the lens technology. Weed surely was using some adaptation of a portrait lens. It has a very long focus by comparison to the lens that Watkins used. There are at least two precedents for larger cameras in California, but the photographers who used them did not go to Yosemite, and we do not know the exact dimensions of their cameras. Watkins apparently paid very close attention to the evolution of equipment. I think it's to his credit that he understood the need to bring larger equipment in and to perfect his technology to accomplish prints like this.

DF: Do you have a sense that he perceived images of this size as being commercially viable or was he doing them more as a speculative venture?

PP: There's a big problem with this, because I feel that his pride of accomplishment far outweighed the idea that he would profit significantly. He wanted to challenge himself. He produced this large work because he had a narrow circle of friends who were admiring what he was doing and encouraging him. The reward was getting to this point of accomplishment and having a select audience that was pleased, but then he began to realize that he couldn't continue without getting some cash benefit.

WN: His European counterparts had also begun to use large cameras. Gustave Le Gray, who was essential to the transition from the paper-negative era to the glass-plate era, made an astonishing series of seascapes and cloud studies beginning in 1856. In 1862 Francis Bedford took a mammoth-plate camera to Egypt and photographed the pyramids. Watkins would fall between Le Gray and Bedford if you were to list photographers who were making display-sized pictures using the mammoth camera. This is an important point, because it places him in an international, not just a regional, context.

DF: What level of awareness might he have had of Bedford and Le Gray?

PP: Watkins, like all the photographers, was very good about keeping up with the literature. If something appeared in *Humphrey's Journal* or the *Philadelphia Photographer,* he would certainly have been aware of it.

DR: Do you think it's fair to conclude that Watkins's use of the mammoth-plate camera was a response to Yosemite's bigness?

PP: Absolutely. The word *grandeur* seems to imply this grand view, this grand object, this grand participation.

DF: An interesting comparison can be made between Watkins's photographs and the paintings of Albert Bierstadt, which also have a sense of grandeur.

WN: Let's look at a reproduction of Bierstadt's 1864 painting *Valley of the Yosemite* (p. 107), done three years after Watkins's initial trip there.

PP: Bierstadt first traveled across the country from St. Louis on the Frederick Lander expedition in 1859; he made a series of stereographs on that trip.

WN: So he would have been aware of the potential for photography to influence his painting. When Bierstadt returned to the West in 1864, he made a number of paintings in Yosemite, including one of the Grizzly Giant that would appear to be based directly upon Watkins's photograph of that huge sequoia. The circumstantial evidence is that Bierstadt and Watkins were in Yosemite at the same time.

PP: In fact, Watkins later sold a large number of photographs to Bierstadt for six hundred dollars. Bierstadt refused to pay for a while, but it was later settled.

AR: Peter, wasn't the first step in this relationship that Bierstadt saw Watkins's photographs in a New York gallery?

PP: Yes, at Goupil's Art Gallery, in 1862 or 1863.

DR: Given that relationship, it is interesting to note that Eadweard Muybridge, not Watkins, was the photographer with the Bierstadt party in Yosemite in 1872. Muybridge made some pictures of Bierstadt painting.

Albert Bierstadt. *Valley of the Yosemite*, 1864.
Oil on paperboard, 30.2 × 48.9 cm.
Gift of Martha C. Karolik for the M. and M. Karolik
Collection of American Paintings, 1815–1865.
Courtesy, Museum of Fine Arts, Boston.

PP: That's right. This hearkens back to the fact that the artists and the photographers knew each other. Watkins went to Yosemite with Thomas Hill and later worked with Gilbert Munger and Virgil Williams. In some cases he produced mammoth-size prints of their paintings, so there is a technical relationship as well as an aesthetic one. In 1873 Watkins went back to New York to visit Edward Bierstadt, Albert's brother, and to learn the Albertype process, an early photomechanical printing technique.

DR: This particular painting by Bierstadt is not very large; it's about the same size as the Cathedral Rocks mammoth plate.

WN: The difference between the Watkins view and the Bierstadt painting is that the painting is far more picturesque and romantic. It involves brilliant color and anecdotal elements, such as the deer in the foreground. When the two pictures are

looked at side by side, the photograph clearly has the appearance of being more documentary, which raises the persistent question of where the art in photography is.

TF: Bierstadt's painting is panoramic; the photograph is really very focused. It brings into play Watkins's experience with stereographs. This would make a very good stereograph.

We talked about the international context of Watkins's work, but if you wished to use a single photograph to attach him to American literature and art on a national level, this would be a very good one to choose. It has a formula he often employs—entry on a flat plane, the picturesque in the foreground, and an image of power and the sublime in the background. He has framed the sublime in the picturesque, and that ties him to the crosscurrents of American thinking at the time in literature and art.

There are other views in which the Cathedral Rocks are more or less aggressively portrayed, but this is the one where I think he finds a medium range by masking it very carefully in the picturesque. It's an image of the power of nature, but it's a cultured view of nature. The culture is the foreground, in which nature has been controlled and artistically portrayed; nature, and the power and sublimity that were coming from European thought, is actually in the background, in Cathedral Rocks.

DF: One of the dichotomies that I've always wondered about is that a painter like Bierstadt can achieve the sublime through these atmospheric clouds and colors, but, because of the light sensitivity of the wet-plate emulsion of the glass negatives, Watkins was not really capable of capturing any clouds that might have been there. To hear you talk about achieving sublimity through the structure of the photograph is interesting.

TF: It took me a long time to see it that way, but the sublime was a complicated concept. I'm talking about the part of it that involves fear and awe, while the picturesque reduces things to easily assimilable elements.

DR: If you compare this photograph with the Bierstadt painting, I think you come upon one of the fundamental puzzles of the history of art in Yosemite, which is

why photography became the art form there. By 1900 there were no major painters working in Yosemite; important twentieth-century painters have worked there only on casual visits.

Here is a possible explanation. Watkins and Bierstadt were both clearly interested in the sublime. When Americans viewed Bierstadt's work, they said, "I'm not sure that sublimity is really in nature; it may really be in Bierstadt and the way in which he can rearrange the furniture of Yosemite"—which he has done in this painting. Those same Americans looked at a Watkins photograph and said, "This sublimity is really there." I don't know how self-conscious Americans were about this, but that seems to me perhaps one way of explaining how black-and-white photography became ascendant. We, of course, have become much more sophisticated about how photography itself manipulates things, but people at the time could believe this as actually being there, as opposed to being the creation of an artist's vision.

In the 1860s Watkins and Bierstadt were basically on a par in terms of popularity and public response, but over the next few decades painting simply dropped out. Bierstadt went out of popularity, fewer and fewer painters traveled to Yosemite, and more and more photographers went in.

TF: I think that's a very good point. The Civil War also had an influence on both coasts. At the beginning of that period, paintings and prints were the standard for information, but by the end of it, photography was. Like fiction, painting tends to produce a truth of its own. Photography was the only medium that could do justice to Yosemite. When people realized that, the world changed considerably in its views of representation.

WN: What I find interesting is the different means by which these two artists, one with a camera, the other with brush and paint, achieve the sublime. Watkins achieves it by focusing on his subject and providing such a totally delineated view of this massive and yet poetic rock form. It's almost as though he's using a telephoto lens; he's somehow causing that massive pile of granite to occupy such a central position in the picture.

We should remember that it's not easy for this pile of rocks to be given that centrality, because it doesn't really occupy that position. It's surrounded by

other distracting forms. The genius here was choosing the right point of view whereby the trees on the left and right obscure just enough of what he needs to have blocked out so that the rocks loom up in this extraordinary way and, because of their looming quality, persuade us of their cosmic force.

The Bierstadt painting is really unsuccessful in dealing with the rocks. They're kind of flabby; they have no detail whatsoever. They seem confectionery for some reason, and that is, in part, a result of this bright, yellow-orange light that itself is the vehicle for the sublime. Bierstadt is translating a geographical experience, yet he's not really able to capture that soaring quality in picture form. He has to use a crutch, this brilliant color that comes from what would be a setting sun. The sublime here, in my opinion, is very European in its flavor.

We know from the very first photographs we saw today that Watkins was very concerned with light, but in *River View, Cathedral Rocks* he had no way to make light be anything other than the modeling force. This is a picture where light has been harnessed in the most skillful possible way, not as a crutch, but literally as though it were the creative element that is causing the whole thing to be feasible.

TF: I want to introduce the concept of morphology. Watkins was very sensitive to shapes, and his views of the Cathedral Rocks, the Three Brothers, Sentinel Dome, and El Capitan all capture the personality of these places. The formations can be portrayed in many different ways, but Watkins frequently finds the definitive view. That is clearly one of his abilities. He also has an extraordinary, almost uncanny, sense of volume, which is an important aspect of his landscape work.

WN: Watkins is proving here that the choices the photographer has are twofold: where to put the camera, and how the light is used to create the picture. He is demonstrating such mastery over his materials because these are two simple choices, and the choices he's made are so perfect that together they become part of the sublime. The perfection of his choice of light and point of view seems to be not only intelligent, but intuitive.

DR: One way of explaining this would be that Bierstadt is essentially operating out of a European tradition of painting that goes back to the Renaissance, in which God is associated with clouds. Here you have the geography of Yosemite, rearranged to

be sure. The light from the sun is coming from the west as it sets, but the code is essentially the same: out of the heavens comes revelation.

With Watkins, I think it's very difficult to read to what extent this is an aesthetic decision and to what extent it's the function of the medium. Watkins simply can't do certain things that Bierstadt can. For Watkins, the rocks themselves become the locus of value. It seems to me, then, that if you consider what Weston just said, and what Tom said about volume, the volume of this rock and the light shining off it focus attention on the rock, not on the atmosphere, as is almost always the case with Bierstadt.

To take it one step further, Americans were likely to be less familiar with European traditions and also to be looking for ways to make themselves distinctive. After all, the first version of *Leaves of Grass* was published in 1855. Walt Whitman was looking toward the grand American landscape as giving Americans value, so the people back east who were reading Whitman could look at this photograph and say, "Aha! That's it. This is where our value is, right there in that solid rock."

DF: Following up on the idea of Watkins's ability to find the best view of a scene, in *From the "Best General View," Mariposa Trail* (pl. 11) he has actually put that phrase in quotes in the title. This is perhaps an indication of the extent to which Yosemite had become part of the public iconography by the mid-1860s. This is a smaller-scale, 7⅝-by-11⅝-inch print, dated 1865 or 1866.

DR: Charles Weed made a photograph from this spot a year or so before (p. 112). It's from a place called Mount Beatitude; I have been out to it on three different occasions. There is no trail, and you have to go through about a hundred yards of extraordinarily dense chaparral to get there. Weed and Watkins established this particular viewpoint as a classic location from which to look at the valley, but the Park Service has deliberately decided not to build a trail out to it.

The central tree in this image is a conifer. When conifers grow by themselves, they do not lose their lower limbs. That happens only when they are in shade, in a grove. The theory is that people cut off the lower limbs of this tree because they were obstructing too much of the view. Perhaps Weed cut some to

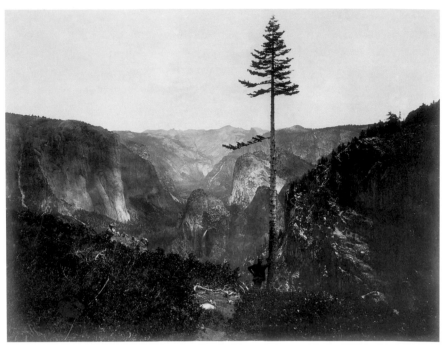

Charles Leander Weed.
Yo-semite Valley, from the Mariposa Trail. / Mariposa County, CAL.,
1863–64. Albumen print,
39.6 × 51.6 cm. 85.XP.15.5.

make his photograph. In his image, there is another branch that either fell off or was cut off before Watkins photographed here.

WN: I was unaware that this place is not easy to get to today, and probably wasn't then. Weed and Watkins found their way to the very same perfect viewpoint, and they both chose to photograph with this lone conifer at the front edge of the composition. Weed allows the tip of the tree to be completely evident, letting this picturesque element retain its integrity.

PP: Weed also included human figures in his picture, which of course Watkins seldom did in his large prints in the valley.

WN: In his picture, Watkins has made deliberate choices that tell us a little about his personality. The most important of these is the removal of the branch that appears in Weed's photograph. I'm assuming for the sake of argument that Watkins removed it. I don't know why I feel that; I just think he did. We know that he made a practice of tidying up subjects in order to achieve his own sense of symmetry.

Watkins has cropped the top of the tree at an odd place, such that we don't see the tip. We're left with the top of the picture unresolved, in the classical sense. What would the difference in function be between placing the tree at the very front of the picture plane, to use a modern term, or placing it as an independent sculptural element and allowing the top of the tree to be exposed?

PP: It seems to me that once he lowers the camera, so that the treetop is cut off, the tree becomes a formal element that you look beyond.

WN: Exactly. It's a purely formal element. How does this treatment of the tree in the foreground relate to the whole concept of the picturesque? I am interpreting it as being antipicturesque and pointing toward a modernist, more formalist sensibility. He is dealing with a given in nature as a purely formal tool to be harnessed for its effectiveness.

PP: Why didn't Watkins cut the tree down? Without the tree there, it's truly a different image.

DR: On this promontory you don't have to take the picture from this exact point of view. If you go out beyond the tree, as I have done, and make a photograph of the valley, you later wish the tree were there, because the image becomes all background. It's pretty uninteresting.

TF: The tree introduces complexity. There is an array of visual elements here with the hills and shadows and space; without the tree, you'd take them for granted.

DF: There's very little pictorial information to the right of the tree trunk. If it became the right edge of the picture, assuming that the branches on the left also disappeared, the whole image would be strongly affected.

WN: I had never noticed what a powerful, menacing, but effective visual element that deep shadow to the right of the tree is.

PP: In looking at the Weed and Watkins photographs together, I think Weed was standing farther back. Watkins has moved the camera a little bit closer to the tree and raised the horizon in the photograph. In a very subtle way it opens up the view; you feel the volume of the valley itself.

DF: Let's look now at another intermediate-sized picture called *The First View of the Valley from the Mariposa Trail* (pl. 12), which again is from 1865 or 1866.

WN: We need to talk for a moment about what constitutes originality in photography. Since photographers must deal with givens, we know that originality, in one sense, is being first at a given subject. In the case of *From the "Best General View,"* Watkins had to admit that somebody else—Weed, his friend and competitor—was at the "best" viewpoint before he was. He had to live with that, and he lived with it long enough to create a composition that, I think we'll all agree, was more perfect in all of its essential details than the predecessor. How does he go one step further and find the viewpoint that has not been photographed before, that becomes totally his property? That would be this *First View*, but why didn't anyone else photograph it?

DR: I think there may be a fairly simple answer. It's difficult to reconstruct exactly where the Indian trail was that went from the town of Mariposa to Wawona and from Wawona to the valley. If you look for this spot near the present-day trail, you'll have a difficult time finding it. This may be because the trees weren't so dense then. Of all of Watkins's great photographs, I think you can make a case that he prospected for this view off the trail, trying to get out to a spot where the valley would open up in a much more significant way.

WN: I'm astonished by how good this picture is, how extraordinarily powerful the composition is for a variety of reasons. One is the way Watkins has used the framing elements—the tree at the left and a counterpart tree at the right—to give some foreground interest. Another is his choice of light to reveal that breaking shadow in the middle ground. The shadowy front is such an important part of this photograph, as is the delineation of El Capitan. This picture is all about the power of light to articulate the various forms.

PP: Our enthusiasm for this image is shared. J. D. Whitney, head of the California State Geological Survey, wrote in a letter to William Brewer on July 5, 1866: "Watkins is on the spot, with the most wonderful camp, & has taken many fine pictures, some of these I think will surpass anything he has ever had—Especially the trail views from the Mariposa Trail & a spectacle from a spot two-thirds of the way down which we all think gives the best general view of the valley. . . . Watkins thinks his best pictures." From this you can see the enthusiasm of people who knew geological features and whose job it was to record them and talk about them as science—but their enthusiasm is certainly one of vision.

DR: There is one aspect of this photograph that struck me some time ago. We're not looking at a mammoth-plate print here, but he did take a mammoth plate of this. It, more than any other of his mammoth plate images, seems to incorporate some things he learned from stereoscopy. In a stereograph, you have the sense that the picture occupies your entire vision; you don't see where you're standing. The way the rock falls off in this photograph, there is really no foreground, and everything in the foreground, namely the trees, is coming up from a place you don't see. It's as if visually, and perhaps emotionally, you're suspended.

WN: Right. It's as though the camera were levitated. He's created an illusion.

DR: That illusion gives you a visual, emotional sense of how deep the valley is. Whereas *From the "Best General View"* seems to present the volume of the valley, this one presents its sense of depth. It convinces you it is a long way down.

AR: This beautiful image is also very disturbing to me. I feel that at this point Watkins is beginning to play with the kinesthetic response that he gets from the viewer. David mentioned that he thought he was going to pitch forward when he looked at the Three Brothers inverted in the glass stereograph (pl. 4). This one does the same thing. You feel like you could just fall into that space; there's nothing to stand on. Also, there's a knifelike edge of rock coming at you like the prow of a ship. To me, this seems like the dark side of Watkins starting to emerge. This may be the first image where he does something that is not just a very subtle intellectual exercise with composition, space, and light. He's describing something inside himself, and that is a place he revisits later in his career.

TF: This photograph has a tremendous amount of energy and tension, which represents a real accomplishment. Its force comes from the juxtaposition of the rocks with El Capitan. The massive El Capitan approaches this rock face on the right from above, which is quite astonishing. It's very unusual, and it's really a masterpiece.

WN: You mentioned, David, that this is not a mammoth print, so one question that comes to mind is whether Watkins photographed the view with a different camera. Peter, have you compared this print with the mammoth plate?

PP: Yes, and it is not the same. There are differences in the shadows and in the placement of the branches.

WN: So it can be concluded that Watkins had two pieces of equipment there, unless he used one big camera and had a reducing plate so he could photograph on a smaller piece of glass. He first had to blaze a trail to find the best place, then he had to get at least three cameras there: a mammoth-plate camera, two feet by three feet, with a five- or seven-pound lens; a second camera half that size; and a twin-lensed stereoscopic camera, because we know there's a stereograph of this scene as well.

PP: And a fourth camera, the one that made the full-plate views that were used in Whitney's *Yosemite Book*. I don't believe it has a view from this position, but certainly that work was going on at the same time. Watkins would have had all four pieces of equipment, assuming there were the four formats, and a team of assistants. I speculate that the large and small images were done virtually simultaneously.

WN: So what we are describing is a situation whereby the unique personal vision of the photographer could not be realized without a team of assistants. There would have been eight or ten pack horses and five or six people. This is very different from the solitary experience of Edward Weston photographing on Point Lobos.

PP: William Brewer describes the task of getting into the valley in a letter to Whitney on August 14, 1865: "Watkins is just getting in then [meaning early July] with materials for a big 'take' there & back—over 2,000 lbs. of baggage, glass for over 100 big negatives."

WN: In the Bancroft Library there is a little notebook of Watkins's expenses called the 1864 Daily Pocket Remembrancer. In this notebook we see that his total income for 1864—and this is gross, not profit—was $2,926.22. This was a big number, because thousands of acres of land could have been bought for $3,000. It suggests that in 1864, when photography itself had only existed for twenty-five years, Watkins was riding as high as you possibly can, earning as much as most studio photographers probably would have earned making portraits.

PP: He was making a very good income then, but that success did not last. In a letter Whitney wrote to Brewer in March of 1866, he said: "Watkins has been as poor as poverty all winter. In the first three months after he returned from the Yos. he did not get $200 of orders, of late things have picked up a little." Watkins soon learned of forgeries being made of his work. He was not making money with these images and he was being robbed; in 1867 he began copyrighting his images to protect himself from this activity.

WN: In terms of his biography, we could interpret this image as Watkins stretching to satisfy his market and saying, "What miracle can I perform so they will pay me grandly and handsomely for my genius?" One of the reasons he commands our respect is that when he is challenged to satisfy his own needs, instead of doing what William Henry Jackson did, which was to create a more popular image and a more popular format, Watkins probed more deeply into himself, along the lines of what Amy was saying, into a darker side of his personality, thereby creating a higher form of art but a lesser form of commercial viability.

DR: This idea of the dark side of Watkins seems as intriguing as anything else about him. If you read nineteenth-century accounts of trips to Yosemite, particularly by people who were seeing it for the first time, it is astounding, especially to us in the twentieth century, how frequently those people felt fear. There's one account of a visitor coming into the park who meets some people leaving. He asks why they are leaving, and they say that the place is overwhelmingly oppressive.

Watkins probably would have met Clarence King in Yosemite in 1866. King was an outstanding nineteenth-century scientist and writer who felt this dark side. His journal from that year is in the Huntington Library, and it is remarkable how dark his vision of Yosemite is. I am wondering if there is some possible influ-

ence here. It is not that Watkins didn't have a dark side, but that the people who were coming in, particularly King, were feeling afraid, feeling awe in the sense of fear, and they were bringing this element out in Watkins.

WN: We should consider what kinds of talk there may have been around the campfire with King. We know from his biography that he was a saturnine individual who had his own highly personal theories about the origin of the Earth and that catastrophism and the role of ancient cataclysms were the basis for his research in geology. He would have looked for the cataclysm that caused this valley to be carved out of the surrounding granite.

DR: King was the first person to note the influence of glaciers, several years before John Muir, but the evidence is unclear as to whether King abandoned his glacial theories in response to Whitney's theory that all this land was essentially level and that the bottom dropped out—not all at once, but over a period of time, as we would imagine of geological events.

WN: This gets away from the dark side of Watkins and makes this image into a geological illustration.

DR: But the catastrophism and the dark side are related. Some of the very early visitors to the valley give a description of what they have seen and then include a quote from the Book of Revelation, in which God is descending in wrath over the whole Earth. What I'm trying to do is to fill out this notion of a dark side.

DF: We should look now at the kinds of pictures Watkins made following his successful explorations of Yosemite. *Cape Horn, Columbia River, Oregon* (p. 119; see also pl. 16) is one of the mammoth plates from Watkins's expedition to that state in 1867. This image was taken on the Washington side of the Columbia, from a point where there was a little farm and an apple orchard. The rock formation on the left side of this photograph creates space in a similar way that the shadow does on the right side of *From the "Best General View."*

TF: I don't think it is disparaging Watkins to say that there is a formula here. He very clearly works frequently with the same elements; they get bigger and smaller, but this is a good example of that motif.

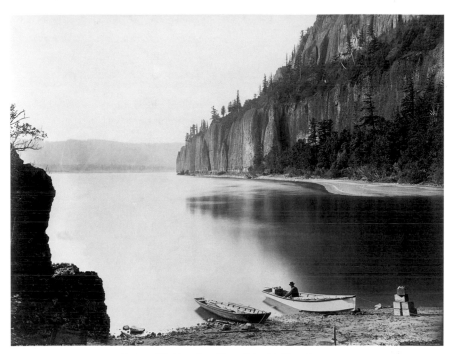

Carleton Watkins. *Cape Horn, Columbia River, Oregon.*
Circa 1881–83 albumen print from an 1867 negative,
40.5 × 52.3 cm. 85.XM.11.2.

WN: Those elements are, as we have seen again and again, a strong foreground—here the boats and the boxes, along with a curious little post—then at either side, the powerful framing devices that keep the composition totally contained within the edges of the picture.

DR: Would it be appropriate to say that this belongs to the luminist school of American art, or is that taking the application of such labels too far?

WN: Well, I think it fits perfectly in the spectrum. It's a little on the late side—it would be at the end of luminism—but it certainly has elements in common with Fitz Hugh Lane and other East Coast painters.

DR: Would Watkins have had any way of seeing their material?

WN: Not so far as we know.

DR: Does this picture look luminous because of the nature of the photographic process Watkins was using? If that is the case, then this is simply a coincidence that has no significant place in art history. Or did he select the view and present it in this way because this was part of the zeitgeist?

TF: It's very difficult to determine. It's hard to know what art was where on the West Coast, but I find it difficult to believe that someone who grew up in New York State at the time Thomas Cole and other artists were painting would have known absolutely nothing. Also, things did travel by reproduction.

DF: At the same time, the quality of light that Watkins would have confronted in Oregon along the Columbia River in June was very different from what he faced at an elevation of four to six thousand feet in Yosemite. To a certain extent, the luminosity in this photograph reflects what was there.

TF: You can also point to what isn't there. There's nothing baroque or busy in Watkins's work—he is related to the luminists in that way—but without some documentation I don't see how you can really make him part of that movement, although the relation has certainly been written about.

WN: In my opinion there are problems with this connection, because on the one hand, this work is very formal, and on the other hand, it's very anecdotal. The two little boats in the foreground are so humble by comparison to the formal, stately permanence of, for example, Lane's vessel moored in the harbor at Ipswich and bathed in luminous light.

I would say that part of Watkins's genius here is the casualness that the anecdotal elements have and the formal rigor that is insinuated into the rest of the picture, such as with the shape of the rock at left. The drawing of the sinuous coastline on the right is so sensual and so opposite the sinister quality of that rock. This is a kind of formalism that rises to the supreme levels of accomplishment, with the formal and the anecdotal brought together in such total harmony. This image takes picture making to a whole new level in terms of integrating the elements, and that, for me, is why it's such an extraordinary masterpiece.

DR: Think too of the painters that Watkins would have known about—William Keith and Thomas Hill.

PP: He had a close relationship with both of them.

DR: They both put casual observers in their big canvases—people who were walking along, often Native Americans. These figures are always quite small and always involved in informal actions. I wonder if Watkins learned some things from Keith and Hill.

WN: Watkins proved himself a superior artist by virtue of his power to integrate compositions. The problem with Hill and Keith is that, like all relatively less-talented painters, their work lacks integration from edge to edge. Watkins triumphed like a painter because he integrated his pictures edge to edge and top to bottom in an extraordinary way.

DR: This is certainly a wonderful example of that.

DF: We've talked about Watkins beginning his work in photography in the cities of San Jose and San Francisco. He continued to record urban events despite his travels. This stereograph is titled *Montgomery St., from Austin's Building, July 4, '65, S.F.* (pl. 9). Amy mentioned earlier that Watkins's career was blossoming during the time of the Civil War. If you consider that Lee surrendered to Grant on April 9, 1865, the event depicted here is not just any Fourth of July celebration, but the first one following the war. My thought is that Watkins may have photographed it for commercial reasons.

PP: That's correct. Watkins often had his facilities in the Austin Building, but because he was not doing portraits, it's unclear whether he had a rooftop studio or not. He would have had to make prints in sunlight, so he may have had access to the roof, which is probably where this was taken.

AR: There is another image in this series, looking the opposite direction, that shows a gigantic triumphal arch. It has a lot of striped bunting; it's one of those great instantaneous views of flags moving in the wind. In 1865 people would have seen both of these photographs as confirmation of the urbanness of San Francisco, of the city's ascendancy as a major commercial and population center on the West Coast.

WN: A key issue here has to do not just with documenting a historical event but also with Watkins's approach to the concept of instantaneity. One tendency in photography between 1858 and 1860, which first emerged in Paris, London, and New York, was that of using stereographs to record what were called "instantaneous moments." This was a first step toward what we take for granted today as the virtue of photography: its ability to stop an event that is in the process of unfolding.

All of the works by Watkins that we've seen so far, with the exception of *Yo Semite Falls* (pl. 3), have been ones in which he excelled at recording still events—landscapes—that were largely under his control. Here he is demonstrating yet another side of his personality that will become increasingly important in the 1870s and 1880s.

DF: Would he have been able to photograph this with an exposure short enough that he would not need to wait for the parade to stop?

PP: That's a good question. I think it's a matter of a quick uncap of the lenses. He may not have done a mammoth view of this because the exposure would have been much more prolonged with the larger camera.

WN: The other aspect is that he's chosen a viewpoint where the parade is coming directly toward him, so the actual motion is minimized by the direction of travel.

DR: I may be overanalyzing this, but you can see some of the Watkins hallmarks here, such as the dark space on the left side. The series of flags reflects the way he tends to portion out elements like horses and trees. He certainly seems to have realized the nature of the stereograph with the parade coming forward so it will seem to spread out to the viewer. It's hard to know how conscious he was about it, but presumably he could have photographed straight down or in another direction.

DF: While this image looks away from Market Street, the next photograph, *Palace Hotel, Montgomery Street, San Francisco* (pl. 39), looks toward it. This is in the boudoir format, 8¼ by 5 inches, and was made about 1885.

WN: It is worth noting that we're now entering a period where it becomes more and more difficult to date Watkins's pictures with any precision.

AR: This is a stunning image; it's Atget-comes-to-San Francisco.

TF: One thing we can see right away is the large, dark element in the composition. It's notable how frequently that appears.

DR: The clock marks the time of the exposure at exactly one minute to six. Are we guessing that this is a.m., not p.m.?

DF: I was just looking at the shadows. The camera is looking due south down Montgomery. The light is clearly coming in from the left, from the east, so this would be morning.

PP: The exposure is long enough that the carriage and the people on the sidewalk are blurred, indicating the lower level of light found in the morning.

WN: I think the clock is quite an extraordinary element. It underscores what Amy said about the validation of the cosmopolitan character of San Francisco. This is clearly a big city. The Palace Hotel is seven stories tall!

AR: My guess is that Watkins would likely have been fascinated by that clock as a precision instrument.

WN: You mentioned the feeling of Atget in this, but it might be useful to compare it with other European work. We related the Yosemite landscapes to Le Gray; what comes to mind here are Bedford's London views. If I didn't know this was San Francisco, I would have first thought that it was a Bedford London view. He showed similar times of day when the lighting was very dramatic. There is a romance to this picture that goes beyond the ordinary. It also calls to mind Thomas Annan's images of the narrow streets of Glasgow, where a similar dramatic light was chosen even though the subjects were often workers' houses that were not very beautiful. James Valentine also made city views similar to this around the Midlands.

PP: This is a good piece of work with a view camera in the sense that the lines are vertical. Watkins's vantage point is really quite central; he's not high, looking down, nor is he so low that it creates a perspective problem. It's a very competent architectural photograph.

AR: He's also grounded very securely on the street. This really gives you the feeling of being a pedestrian. There you are right next to a gutter with some water running in it, walking through that urban space.

DR: It occurs to me, going back to *River View, Cathedral Rocks* (pl. 5), that one could imagine the Palace Hotel occupying the same central spot that the Cathedral Rocks occupy. In Yosemite, Watkins can keep the trees below the rocks, but in San Francisco, of course, he can't. He has framed this so that, with the exception of some illumination on the right side of the picture, it's the hotel that's mainly in light. The notion that the design here is intended to show off the hotel as an equivalent human monument to the natural monument of Cathedral Rocks makes some sense.

AR: One other thing to keep in mind is that, although the date is unsure for this photograph, in 1880 Watkins traveled on the Southern Pacific Railroad as far south as San Diego and as far east as Tombstone, Arizona. He was experiencing a very noncosmopolitan kind of environment there. He wrote home to his wife about the "mud city," which was Tucson, and complained bitterly about the horrible heat and dust that made photography impossible. Here, he is in San Francisco's delicious, moist environment that gives him this kind of light.

TF: We talked about this photograph as having both the hotel and the clock as the subject. If the hotel is the subject, Watkins has very cleverly given it an environment. If the clock is the subject, he's placed it carefully in an urban landscape. If they're both the subject, you have a good picture of a neighborhood, a kind of cultural view. There's a lot going on here.

WN: Does this show where he had his gallery?

PP: His Yosemite Art Gallery was at 22–26 Montgomery, down the block on the left. This is his neighborhood; we are seeing a portrait of something he knows well.

WN: I think Tom's point of this being an environmental image is good. With the Cape Horn photograph (p. 119), the skeleton of the picture was so simple that you couldn't avoid seeing how clearly he constructed it from foreground to background and edge to edge. The same feeling is here, but it's harder to comprehend because you can't really tell whether the foreground or background is the actual subject.

TF: Watkins seems to do that by using shadows to unite different aspects of his subject. In this image the shadow on the hotel makes the left and right sides of the picture read together. In the Cape Horn print the reflection of the rock wall in the water encompasses the cliffs into one large form.

DF: With the next photograph, *"Agassiz" Column, Yosemite* (pl. 27), from 1878, we are following Watkins back to the scene of his best-known work.

WN: This is a vastly different picture. It's small, just five inches in diameter, so we're now returning to questions of scale. Perhaps most importantly, Watkins has chosen a round format, one he seems to have favored in the period between the late 1870s and the 1890s, especially insofar as album prints are concerned.

AR: Why did he favor that, do you suppose?

PP: I think he had a dramatic experience with the loss of his gallery in 1875. He was extremely bitter and realized his aging, vulnerability, and lack of family. He also had a romantic interest; Watkins fell in love with Frances Sneade—"Frankie"—in this period. He began to shrug off the weight of the world, turned inward, and began to look at the pleasurable side of the landscape. He pushed it and manipulated it, and the shapes of the prints made it somewhat more pictorial. I think he did this both in consultation with some of the painters he knew and as an exploration within himself. He did an immense amount of work in the summer of 1878; many of the shaped prints come from that time. We find them not only round, but dome topped, as elongated ovals, and in various other formats. He generally sold them on cabinet or boudoir mounts, which made them more affordable to the public.

WN: When they were married in 1879, Frankie was twenty two years old and Carleton was fifty. This reminds me of Alfred Stieglitz and Georgia O'Keeffe. We don't know what qualities Frankie had, but she inspired Watkins to make work of a kind that he hadn't made previously.

PP: My feeling is that he was in love with the idea of love, and Frankie was the beneficiary of that. He gave her a book of poetry, which survives; there is an inscrip-

tion in it in his own hand. He is expressing his feelings in a way that we do not see heretofore.

WN: The formal properties of this little picture are really quite stunning. We see once again the formula of treating the edges as framing elements, but here he's reinventing himself, balancing the rock on the left with the boughs of the pine tree on the right, which somehow seems a wonderful formal conceit.

AR: This is one of the scenes in Yosemite that he photographed frequently over the years. Some authors have suggested that they can see growth in his art by comparing the later images to the earlier ones.

PP: This is from the New Series. Since he had lost many of the Old Series negatives in bankruptcy, he was now revisiting previous sites.

WN: There is a mammoth plate of this by Watkins, printed by Taber, that was reproduced in *The Era of Exploration* (1975). We know that it had to have been created before 1875, because that's when Taber got Watkins's negatives. When Watkins visited this site around 1872, he chose a very different viewpoint—the rock is seen in a different profile and with another background.

AR: Since the image we're looking at comes after his financial disaster, can we see something different about the way he works? People have claimed that there is a difference in the way he approached the landscape after that.

PP: There is a significant amount of forced perspective in this new work. He is using a lens with a wider angle, and there is much more spatial development, which the changing of the format outline tends to reinforce. In the mammoth view the rock sticks up above the horizon so substantially that it distorts the relationship with the rest of the land. There is a more integrated association in this small, round image.

WN: Right. The problem in the mammoth plate is that the horizon line of the valley actually interferes with the monumentality of the rock itself. Taber tried to compensate for it by underprinting the background. I am absolutely astonished by the viewpoint in this 1878 composition. Somehow there's an element of perfection here; it's a miracle that Watkins could see it in quite this way.

DR: I think that we are all reading the circle as giving the photograph a more picturesque quality, and therefore Watkins is perhaps responding to the demands of the public, who might buy such an image before they would buy one that was more formal. Is that a reasonable assumption?

PP: There is almost no evidence that he sold round pictures to the public. I can't recall having seen much like this in made-up albums or as loose prints for the public.

WN: This is an important element, because we found the round pictures in what seem to be albums that came from very closely held circumstances, essentially family presentation albums of one kind or another. What is perplexing is that somebody has spent a lot of time doing the cutting and mounting.

AR: Was Watkins the only photographer using a circular format?

WN: He wasn't the only one, but there were not very many others. John K. Hillers, for example, did a series of very carefully cut oval landscapes of the Colorado River in about 1872.

TF: It's interesting that this shape as well as other kinds of specialized formats have always been associated with emotion in art and photography. Considering some of the words that have come up in our discussion—*manipulation, pictorial, cutting*—this almost looks ahead to the turn of the century, when this was a common convention.

WN: That's an important point. I think Watkins moves into Emersonian naturalism, which is one step removed from pictorialism.

TF: Another element of turn-of-the-century photography is emotion, but overt emotion, sentimentality, as opposed to the kind of powerful, dignified feeling where, for example, the rocks are revealed in *Cathedral Rocks. "Agassiz" Column,* with its circular setting, is more of a studio portrait. I personally find that Watkins is more successful when he is direct. To me, this is a "this-is-how-I-feel" picture, and I don't find in it the same kind of sincerity that I do in his earlier work. Yes, it's a very good portrait of a rock. One can speak about geology and say good things about the composition, but I don't feel that it has the kind of integrity that some of his earlier pictures have, perhaps because he's not so comfortable in this new emotional territory.

WN: I think *sincerity* is a very interesting word in the critical lexicon that we're developing, because we have painted a picture of Watkins, up until the year 1867, as being the paragon of sincerity. Now we're seeing a new concept in the possibility that he could do something for reasons that were other than his deepest motivations. I think you're absolutely right. There is a superficiality to this picture, and a gimmick with the mask that creates the perfect solution to both edges. He didn't need to previsualize it.

TF: I don't think he doubted that he had taken a good photograph, but the earlier commitment to everything fitting perfectly seems lacking. I think he has a different view of the background here than he had in some of his other pictures, where it had to work completely.

DF: *Surf View on the Cliff Road, Santa Cruz* (pl. 37), from circa 1883, also places emphasis on the foreground, but for different reasons. We talked about flowing waterfalls in Watkins's landscapes and movement in the Fourth of July parade, but here for the first time the primary focus of the photograph is a moving object. There is a sense of a decisive moment when an exposure had to be made.

PP: This is part of an extended series that Watkins made along the Pacific Coast. In 1880 he traveled northward from Southern California photographing all the missions, but he didn't get to the Santa Cruz/Monterey region. He went back that way in 1883 and did the Hotel Del Monte and other work in several formats. It's not clear who the clients were, but there was a significant exploration of the land. This is one of the boudoir views. When Watkins looked this closely at an element of the landscape, I think he was personally intrigued as to whether he could create a particular sensibility that he could capture and carry away with him.

DF: So it's a technical challenge then.

PP: Yes, I think he was very proud of the instantaneity that's displayed here—how well he's captured it and yet retained the structure of the crashing waves.

WN: We've mentioned Gustave Le Gray in connection with mammoth-plate photography; his most celebrated early picture is called *The Broken Wave*, from circa 1857. That was the first picture of a wave crashing, so this Watkins image falls in a

tradition, but it's by no means early in that tradition. Le Gray's breaking wave is quiet by comparison. The wave was coming directly at him, so there was hardly any motion, and it was much easier to create the illusion that he had caught the wave at the immediate point of crashing. Moreover, it wasn't a wave that was literally breaking against the rocks, which is what we're seeing here. For Watkins, the wave was moving parallel to the camera plane, which is the hardest form of motion to arrest, because the wave is moving at its maximum momentum relative to the lens.

This image left a very strong impact on me. Watkins was the very first to record waves literally exploding, and it's that dynamic quality that would seem to give this picture its originality.

PP: He had some previous experience with imagery of this type. He photographed the blowing up of Blossom Rock, which was an obstruction in San Francisco Bay, and a rock in the Columbia River as well.

AR: We also know that three years previously he was trying to do this kind of picture in Santa Monica. He wrote about trying to get the surf breaking there. I would say that here he's captured the "best view" of a wave by going around to the back side of it.

DF: This has the element of intentionality of composition that we talked about before, although here it's obviously serendipitous. The horizon line on the right-hand side can be seen through the spray of the wave, all the way into the main upward thrust of it.

WN: We can't ignore the element of chance here. Watkins can't foresee how this wave is going to explode, except perhaps by having stood on this site and watched a number of waves as they came in. He must have become aware, say, of the rhythm of Yosemite, where the sunlight fell from morning to evening in certain ways that he clearly began to understand, but what we see here was totally the product of accident! This man who had done so many pictures that required his building them from edge to edge and top to bottom, leaving nothing to chance, suddenly, at the age of fifty-three, is giving himself over to accident and chance, which Leonardo da Vinci called "the most powerful creative forces in the universe."

PP: There are other examples from this particular series with water and surging surf, but nothing approaching the success of this. I would guess that he was very proud of this image.

TF: Are there any mammoth plates?

PP: Nothing like this, no.

TF: I think this speaks to the era again. Wouldn't you like to see it as a mammoth plate? The fact that it's in this parlor form means the format almost works against the intensity of the image.

DR: I think I don't share the enthusiasm for this. I'm trying, but mostly this photograph strikes me as a curiosity piece. It's a nice picture, but I think you're much more likely to say about this one, "How did he do that?" That is the type of thing you generally don't say about the great Watkins images. I don't focus on this print as saying something to me in terms of what's in it and how it's composed.

WN: There is another important historical context here related to the instantaneity of the image. Leland Stanford challenged Muybridge to stop the motion of a horse with his camera, and in 1878 Muybridge suddenly became famous for proving that a running horse has all four feet off the ground. He did an entire series where the motion became the key element. Now, if we were to put Muybridge's study of stopped motion next to this, which one would look more like serious art?

DR: Well, this would.

WN: This would look much more like a Gustave Courbet painting of a wave, so I think what we're seeing here is very possibly a response by Watkins to his own immediate environment, to people around him who were challenging him to do something in his own realm that was as good. In my opinion, this would be the direction that pure art takes when challenged by science, and science was what Muybridge was involved in.

AR: At about this same time, F. Jay Haynes was in Yellowstone making mammoth-plate views of the erupting geysers. They were very popular, and he sold immense numbers of them, but I'm not moved by them the way I am by this. Haynes's pic-

tures seem more like tourist keepsakes to me. They're staged, and their lack of spontaneity is boring.

DF: Moving once again back to Yosemite, *Sentinel, View from the Valley, Yosemite* (pl. 22) has been dated provisionally between 1865 and 1885, which seems like an unusually large spread. I wonder if it might be narrowed further.

PP: This is an unrefined date, and I must say it is not going to be easy to narrow it. The reason the picture presently has this broad date is because it could harken back to the 1865–66 trips, but I suspect that it may be 1872 or later. It's one of those things where we don't have good evidence to narrow it further. It's somewhat more traditional in its vision, but it also has some of the more romantic qualities that we see in the New Series.

WN: For me, this is definitely part of the New Series, and the reason I say that is because the foreground is far messier here than in anything Watkins did in 1866 or 1872. I think we cannot ignore the impact on Watkins of Muybridge's mammoth views from his visit to Yosemite in 1872. One of the points of analysis would be how Watkins reacted to the challenge of Muybridge's mammoth plates, which would have been in direct competition with his own carefully produced series.

I would see this image as a direct response, because it has all the hallmarks we find later in the crashing wave photograph. Let's assume that Watkins saw Muybridge as a direct challenger to his primacy as the best photographer in San Francisco, and he had to prove that he could outdo Muybridge one-on-one. I suggested before that the breaking wave was a response to Muybridge. Let's argue for a moment that this is another response to him, and therefore it would have to be made sometime after the summer of 1872. This would have been a response to Muybridge's river views. The Merced River was the one part of the Yosemite Valley landscape that Watkins did not seriously examine in his own mammoth-plate series, particularly views looking straight up the river.

From my perspective, this is a wonderful picture because of the way it comes to grips with all the messiness and chaos that can be found in nature. Up to now, Watkins has dealt chiefly with a classical sense of order, of choosing places and subjects where there was some preordained sense of total beauty. Here we're

suddenly confronted with nature in chaos and decay. I see this as Watkins challenging Muybridge head-on, so I would remove the 1865 date and say it has to be after 1872. In my opinion, it's probably closer to the time of the breaking wave.

PP: I have associated it directly with the work he completed in 1878. I arrived at the same conclusion without the same argument and also think it could be pushed over to the New Series of photographs.

DF: These considerations of dating are very relevant with this final image, *Solar Eclipse* (pl. 41).

PP: I'd like to give a little preamble to this, because two of the abiding issues we have regarding this picture are when Watkins began dry-plate work and what the involvement was of George Davidson, the great geographer and astronomer.

In 1879 Watkins went to the top of Mount Lola with Davidson and did views along the California/Nevada boundary. Watkins was also involved in 1881 when the Davidson party did the Yolo Base Line study. Davidson clearly had great respect for Watkins.

Now, this was still wet-plate photography. As far as I can tell, Watkins began his dry-plate work in 1884, and he continued using dry plates through the end of his creative career. He did, however, return to wet-plate work in mammoth size in 1891 for the Golden Gate and Golden Feather Mines series, but in between he did the Kern County series, nearly a thousand images in the eight-by-ten-inch dry-plate format.

With this image of a solar eclipse, Weston and I responded with our knowledge of a particular event and concluded that the photograph was made at different times, nine years apart. We now need to go back and examine the evidence once again.

WN: Everyone knows that a total eclipse of the sun is a rare event at any given place. Curiously, two total eclipses occurred that were visible on the West Coast within nine years of each other, one in 1880, the other in 1889. Very coincidentally, they both occurred in January, the 1880 eclipse on January 11, the 1889 eclipse on January 1. George Davidson is known to have been involved in observing both of them, but he was most certainly the leader of the expedition to observe the 1880

eclipse from Mount Santa Lucia, which is near Big Sur. This print came from his collection.

I pursued what I believed to be the total likelihood that this had to be the eclipse of 1880. In order to verify that, I went to the newspapers to see if I could find any circumstantial evidence as to what might have been occurring about the time of the eclipse that year. It turned out that on January 9 and 10 a massive winter storm came down the Pacific Coast and left inches of rain; on January 10 the members of the party were fearful that they wouldn't be able to see the eclipse because of the inclement weather. When I learned that and, moreover, since there was a thick cloud layer in this photograph, it seemed to be clear circumstantial evidence that this had to be the eclipse of 1880. However, when we laid out the Watkins pictures for the purpose of creating a chronology based on visual elements, it became very clear that the circumstantial evidence of this particular print— its tonal qualities, surface, size, and all properties pertaining to the print itself— related it much more closely to the 1889 sequence of pictures.

So here we are in a dilemma. Circumstantial evidence of one kind—the storm, the inscription on the back, the association with Davidson—suggests that this is 1880. But on the other hand, the visual evidence says it appears to be more like an 1889 picture.

PP: I've been struggling with your description of the storm, because it is such a wonderful piece of information. But when I look at the image itself, to me this is low-lying fog and not a storm.

DR: Did Davidson observe the eclipse in 1889? And if he did, where was he?

PP: We do not know either answer with certainty.

DR: If this photograph dates from 1889, then where is Watkins standing?

WN: That we don't know, either. The problem is, we don't have an alternative. One of the challenges we struggle with is that every time we are confronted with something like this, it sends us back to search for more information.

AR: In any case, it's a beautiful image, one that startles and surprises us. It looks so modern to our eyes. The foreground is not in focus; you look past the blurred,

dark trees into a sea of clouds. I have the feeling that if this image had been known earlier, Watkins's reputation would have grown a lot sooner.

WN: It would have been very different, wouldn't it.

AR: I'd like to talk a little about the growth of Watkins's reputation. Because of both the scarcity of images by him and the repetitiveness of the types of images that were available, his reputation was established by a slow series of events. What I am tracing here is the trail of crumbs that has led us to this room today—not his commercial or popular reputation, but the way his position became established in the history of photography.

Robert Taft's 1938 book, *Photography and the American Scene,* talked about Watkins. Interestingly, Taft got his information from a curator who had gone to San Francisco to work with Watkins and to inventory his negatives and photographs just before the 1906 earthquake and fire. In 1940 Ansel Adams included some of Watkins's work in the group exhibition he produced called *A Pageant of Photography.* I think it's very interesting that, throughout the centennial of photography in 1939, none of the major histories that were published mentioned Watkins. This silence continued for more than two decades. Josef Maria Eder's 1945 *History of Photography* does not mention Watkins, nor does Beaumont Newhall's 1949 history. John Szarkowski's 1963 book, *The Photographer and the American Landscape,* also neglected Watkins.

By the mid-1960s interest started to build. Ralph Anderson had published an article based on an interview with Watkins's daughter, Julia, in 1953, and Joe Johnson had published an article on the early Watkins photographs in 1960. William Goetzman published *Exploration and Empire* in 1966, which has an entire chapter tracing expeditionary photography and how it entered the established culture.

A big year for Watkins was 1965, when he was included in both *A Concise History of Photography,* by Alison Gernsheim, and *Photography in America, 1850– 1965,* by Robert M. Doty. In 1975 Weston published *The Era of Exploration,* and we all know how important the impact of that book was. I think it took so long to establish Watkins's reputation because no one really knew about the scope of his work.

DF: It's interesting to hear you describe the progress, because in light of the enthusiasm we have all shown for Watkins's photographs today, it's difficult to believe he could have been overlooked for so long.

To conclude our discussion, perhaps we can each detail some personal responses to Watkins and his work.

PP: For me, Watkins has been the monkey on my back that I can't dislodge. I have been intrigued, frustrated, and challenged by him in every possible way. Who is this man? What is his biography? I have been fortunate, I think, in not ever reaching a point where I thought I really knew him. I've tried to be open to possibilities. I've tried to record and document his life and works fairly. This has been an experience I never could have imagined I would ever be involved in.

As we sit here now, I think we have reached a point of some saturation in which we're beginning finally to define more clearly what we do not know. That makes me eager to go back and try to find the missing pieces. Every month something new emerges that we have not known before. I accept that challenge, and I expect that for the rest of my life I will be involved in trying to pull Watkins together and deliver him intact to an audience that appreciates him.

TF: I start from the position that Watkins is a great artist, and I feel very privileged to have been involved in exploring him in some way. Through him, I have found my feet as an interpreter of art and discovered interesting things to express to people about him. That couldn't be done unless there was great material. I think that's relatively unusual in the American art scene; there aren't many world-class American artists, and Watkins would stand up against anyone. His photographs illustrate that he could probably have worked in other media—he has an incredible grasp of form, mass, composition, and light, and those are things that affect artists of all kinds.

I also think that it can be inferred from his photographs that he was at bottom a religious person who had a philosophical interest in his work. That sets him apart, for example, from Muybridge, who I see as early modern. Muybridge was an early modern man with a nineteenth century style; Watkins was a nineteenth-century man with an early modern style. I think the work of each will continue to inform that of the other.

AR: Watkins's works speak to us first because they are so beautiful, and then because he was a man of his time. In knowing his biography to the limited extent that we do, we see that he was also beyond his time in the sense that he was a true artist whose main job in life was to make sense out of his world, to categorize it in ways that made sense to him, and to find structure and purity below the surface of the chaos of this world. That speaks to me across more than a hundred years, and I find that very moving.

There is a poignant and wonderful quote in one of his letters to his wife toward the end of his life that to me sums up what I know and feel about Watkins as a man. It combines a sense of self-irony with a deep philosophical stance that Tom has just called religious. Watkins describes going to a Presbyterian church to hear a lecture, and he writes to his wife that "the man said that the Pleiades were 9 hundred and 99 million miles away." You imagine him being confronted with new scientific facts that astronomers were coming up with and being in awe of the magnitude and scale of this 999 million miles. But then he goes on to say, "And I just said . . . what's the use trying to get to Heaven if it's on the other side of those stars." And that's the self-irony and frustration, part of his dark side, coming through his humor at the same time.

WN: I can recall vividly, in 1980 approximately, when I came to the realization that Watkins is the greatest American photographer before Alfred Stieglitz. His importance, in my opinion, derives from the fact that he created a very large body of consistently excellent work over a thirty-year period and that he was an artist in the very strictest sense of the word. He was probably the first American to show a purely photographic imagination—as opposed to a painterly imagination—that is derived so completely from the process of photography that it identifies itself completely with the medium.

Watkins's subject, for me, is the act of perception itself, and it seems to me that he was trying to prove through his pictures that a well-made photograph was a creation of the heart acting in concert with the eyes and the mind. This reconciliation of form and emotion was exceptional for his time, a period when the documentary spirit seemed to rule over one that allowed the emotions to prevail.

DF: My involvement with Watkins's photographs began in 1979, when, over a very short period of time, The Friends of Photography prepared to publish its edition of his Oregon album. I had seen a few of Watkins's prints, but the experience of sitting down with that album of fifty-one mammoth-plate photographs for the first time would be difficult to duplicate. Ironically, because of our production schedule, I spent an intense four weeks trying to learn everything I could about what Watkins had done in Oregon during an eight-week period 112 years earlier. Being involved in this colloquium has allowed me to become immersed in Watkins once more, and the discussion today has reminded me again of what it means to piece together the life of someone for whom there is little concrete evidence. Each bit of information, however speculative or firmly grounded in history, adds to the understanding and appreciation one can have of Watkins's spectacular photographs.

DR: I think human beings are fascinated by big space. They find it appealing and also very scary. It's the scary aspect that comes through in the letter Amy read. If it's really that big, it's of no use. Until today, I would have said the world of Watkins's photographs is a spatial world, that time is, for all intents and purposes, absent. I think what we saw in the pictures done toward the end of his life is that time very definitely enters in. That's really been an education for me. I would still be willing to assert, however, that Watkins's world is a spatial world. His great achievement philosophically, religiously, and artistically is that he found a way of dealing with space. You always feel that he understands there is a way human beings can deal with bigness and feel good about themselves within this bigness. I think that's a very great achievement.

Chronology

1829

Carleton Eugene Watkins is born in Oneonta, New York, on November 11, the eldest of eight children of innkeepers John and Julia Watkins. As a young man he is an avid hunter and fisherman and active in a local glee club and Presbyterian church choir.

1851

Arrives in San Francisco May 5, one day after a city fire. Stunned by its aftermath, he proceeds to Sacramento, where he is employed by childhood friend Collis P. Huntington (1821–1900) to deliver supplies to the gold mines.

1853

Listed in Sacramento city directory as a carpenter, dwelling with G. W. Murray, bookseller and stationer. Relocates to San Francisco, where he becomes a clerk in Murray's new bookstore on Montgomery Street, one block from Vance's Premium Daguerrean Gallery at the corner of Sacramento and Commercial Streets.

1854–56

Watkins begins photography career by chance, probably in the studio of Robert Vance (1825–76), by filling in for a photographer who had left his post without warning. By March 1856, newspaper advertisements indicate that Watkins is employed by James May Ford (1827–circa 1877) in San Jose, taking portraits by both the daguerreotype and ambrotype processes. By November, the San Jose gallery is taken over by a new owner; Watkins operates as a freelance pho-tographer in the San Jose and San Francisco areas and probably begins outdoor work.

1857

Experiments with wet-collodion process for making glass-plate negatives; produces salted-paper photographs and continues to be interested in outdoor work.

1858

Is commissioned to document the site of the Guadalupe Quicksilver Mine for use as courtroom evidence (*U.S. v. Fossat*). The finished image is composed of two large salt prints joined together to form a panorama of the site. In his court testimony of August 27 he states that he is a "photographicist," that he had personally selected the standpoint for his camera, and that the image(s) represented an "accurate" view. Produces large-format (imperial-sized) pictures of San Francisco and undertakes stereoscopic work as well.

1859–60

Is commissioned to document the Mariposa estate of John C. Frémont (1813–90); employs both imperial and stereographic formats. The Mariposa images form the largest sur-viving body of Watkins's work before 1861. These images are shown to potential Euro-pean investors and Napoleon III. Shares studio located at 425 Montgomery Street, San Francisco, with Ford. Begins associa-tion with the California State Geological Survey. Produces stereographs of the Third San Francisco Mechanics' Industrial Exhi-bition (pl. 1) and a series on San Francisco fire departments. Establishes important social contacts in the Black Point home of Frémont's wife, Jessie Benton Frémont (1824–1902), among them Thomas Starr King (1824–1864), the popular pastor of the First Unitarian Church of San Francisco.

1861

On February 22 photographs crowds of people in San Francisco at a mass meeting in support of the Union (pl. 2); King is keynote orator. Accepts commission to photograph the San Antonio Rancho for the Northern District Court (*U.S. v. D. & V. Peralta);* gives sworn testimony on May 8 and 10. Arranges to have a local cabinetmaker construct a camera capable of handling negatives as large as eighteen by twenty-two inches (mammoth size) and fits it with a Grubb Aplanatic Landscape lens for wide-angle work. In July travels to Yosemite, where he makes at least thirty mammoth photographs and one hundred stereographs of Yosemite Valley and the Mariposa Grove (pls. 3–5). Finishes prints on albumenized paper; signs and titles many of these on the mounts.

1862

William H. Brewer (1828–1910) of the California State Geological Survey views the Yosemite photographs on January 31 and calls them "the finest I have seen." Enthusiastic comments received from King and Ralph Waldo Emerson. By December, Watkins's giant Yosemite prints are placed on display at the prestigious Goupil's Art Gallery in New York City. Mariposa mining views exhibited in London. Watkins photographs members of the California State Geological Survey with the "Carleton Iron" meteorite fragment and records Fourth of July celebrations in San Francisco.

1863

Uses studio at 649 Clay Street, San Francisco, possibly with photographer George H. Johnson (born circa 1823). Photographs King's church and makes a five-mammoth-plate panorama of San Francisco. Yosemite photographs praised in both the *North Pacific Review* and *Atlantic Monthly* (Oliver Wendell Holmes, in the latter, describes the stereographs of Yosemite as being "in a perfection of art which compares with the finest European work"). Photographs New Almaden Quicksilver Mines in the spring and Mendocino Coast lumber mills (pl. 6) in the fall. Publishes *Yo-Semite Valley: Photographic Views of the Falls and Valley.*

1864

Yosemite photographs influential in persuading United States Congress to pass legislation to preserve Yosemite Valley; bill signed by Abraham Lincoln. Relocates gallery to 415 Montgomery Street. Loses prestigious landscape award to Charles Leander Weed (1824–1903) at Mechanics' Fair competition. Actively photographs San Francisco, including panoramic overviews and documentation of the ironclad vessel *Comanche.* Notations in Watkins's 1864 Daily Pocket Remembrancer suggest that his gross income for the year was nearly $3,000.

1865

Yosemite Commissioner Frederick Law Olmsted (1822–1903) consults Watkins on the best means for preservation and use of Yosemite as a public trust. Watkins joins the California State Geological Survey in Yosemite. Begins ongoing series of images of trees and other botanical specimens for Professor Asa Gray (1810–88) of Harvard University. *Report of Progress for 1860–1864* (volume 1 of the *Geologic Survey of California*), by Josiah Dwight Whitney (1819–96), published with woodcut illustrations based on Watkins's 1861 Yosemite images. Mount Watkins, in Yosemite, named in honor of the photographer (pl. 21). Wins award for "Mountain Views" at the San Francisco Mechanics' Fair. Relocates gallery to 425 Montgomery

Street; refers to it as the "Yo Semite Gallery."
Visited by Utah photographer Charles
Roscoe Savage (1832–1909), who is greatly
impressed by Watkins's water-bath techniques
for handling collodion-plate negatives in
Yosemite, "a climate so dry and difficult to
work in."

1866
Extensive reviews of Watkins's Yosemite
work are published in the photographic
press. Continues his work with the Califor-
nia State Geological Survey, making nega-
tives in four sizes: 18 by 22 inches, 9 1/2
by 13 inches (for albums), 6 1/2 by 8 1/2 inches
(for Whitney's forthcoming *Yosemite Book*),
and stereo (two prints mounted side by
side on a 3 1/2-by-7-inch card). Sends six of
his new mammoth Yosemite images to
Edward L. Wilson (1838–1903), editor of the
Philadelphia Photographer, who notes that,
in this case at least, "the camera is mightier
than the sword." Watkins's 1861 Yosemite
images pirated by D. Appleton & Company,

New York, and sold in a reduced size under
the title *Album of the Yosemite Valley,
California.* Experiences persistent economic
problems, because his expenses exceed
income from sales.

1867
Makes a four-month trip to Oregon and the
Columbia River for the Oregon Steam
Navigation Company (pl. 16). Copyrights his
photographs. Wins bronze medal for land-
scape work at the Paris International Expo-
sition and gains a worldwide reputation
through reviews in the foreign press. His
photographs praised at a meeting of the
California Academy of Sciences.

1868
Exhibits fifty mammoth views of Oregon at
Shanahan's Art Gallery, Portland. Whit-
ney's *Yosemite Book* published in an edition
of 250 copies; includes twenty-four photo-
graphs by Watkins. Painter William Keith
(1839–1911) designs logotype commemorat-
ing Watkins's award at the Paris International
Exposition (p. 144). Mounts major exhibit
of Pacific Coast photography at Mechanics'
Fair; wins top award. Photographs Lime
Point project on San Francisco Bay for
U.S. Topographic Engineers. Documents the
wreck of the *Viscata* near San Francisco.
Poses for his likeness in cameo (p. 90),
carved by sculptor Pietro Mezzars (1820–83).

1869
Moves Yosemite Gallery to 429 Montgomery
Street and greatly expands his inventory of
landscape views by photographing geysers,
the Farallon Islands, hydraulic mining, and
urban development in San Francisco and
adjacent towns. Undertakes an ambitious
program of stereograph production, includ-
ing a series on the Central Pacific Railroad
for the *Illustrated San Francisco News.*

Obtains the Central Pacific Railroad negatives of Alfred A. Hart (1816–1908) and publishes them as his own. Begins production of *Yosemite Gallery* albums. Again exhibits at the Mechanics' Fair, where his photographs are praised for "clearness, strength, and softness of tone."

1870

Begins extensive use of an enclosed traveling wagon for field work. Travels to Mount Shasta with geologist Clarence King (1842–1901); ascends to the 14,162-foot-high summit and photographs Whitney Glacier. Exhibits at the Cleveland Exposition.

1871

Becomes charter member of the San Francisco Art Association. Opens lavish Yosemite Art Gallery at 22–26 Montgomery Street using borrowed money; it includes portrait-taking facility and wall display space for 125 mammoth photographs. Travels frequently to expand his inventory of images from all points along the Pacific Coast. Photographs the North Bloomfield Gravel Mines and documents the facilities of the Pacific Mail Steamship Company in San Francisco Bay. Wins silver medal for photography at the Mechanics' Fair, San Francisco.

1872

Invited to join the Bohemian Club. Becomes increasingly involved in San Francisco art circles; photographs the estates of many of the city's wealthiest families. Revisits Yosemite and establishes a separate exhibit and sales outlet for his photographs at the Woodward Gardens in San Francisco.

1873

Travels with Keith along the Central Pacific Railroad as far as Salt Lake City. For the first time, employs two special railroad flatcars to carry his photographic wagon, horses, etc., to distant sites. Accepts a commission to photograph the Carson and Tahoe Fluming Company operations in Nevada. Begins series of images for the *California Horticulturalist and Floral Magazine.* Publishes the Modoc War negatives of Louis Heller (1839–1928). Receives Medal of Progress award at the Vienna Exposition. Travels to New York to learn the Albertype process from Edward Bierstadt (1824–1906); reproduces two sketches by Albert Bierstadt (1830–1902) with the new process. Photographs paintings by Keith and Virgil Williams (1830–86) for record and portfolio uses. Landscape painter Thomas Hill (1829–1908) uses Watkins's photographs as a source of inspiration in his work.

1874

Local business depression hampers gallery sales; price of stereographs drops precipitously all across the industry due to mass production by Eastern publishers. Undertakes commission to photograph the Milton Latham estate at Thurlow Lodge, south of San Francisco; sixty-three mammoth prints are mounted in two presentation albums imprinted *Views of Thurlow Lodge, Mollie Latham, Photographs by Watkins.*

1875

Begins extensive series on Nevada's Comstock mining region (pl. 26), including images inside the stamping mills. Returns to Yosemite. Joins Photographers' Art Society of the Pacific Coast. Continuing economic slump leads to loss of Yosemite Art Gallery and most "Old Series" negatives to businessman John Jay Cook (1837–1904), who had lent money to Watkins. Cook becomes owner of the gallery in association with photographer Isaiah West Taber (1830–1912).

1876–77

Although greatly embittered by the loss of his Yosemite Art Gallery, Watkins begins to replace his lost negatives by revisiting his favorite locations; calls these images his "New Series of Pacific Coast Views." Continues Comstock series, including panoramas of Virginia City, Nevada. Photographs Centennial celebrations in San Francisco. Exhibits at the Centennial Exposition in Philadelphia and wins award at the Chilean Exposition. Travels by rail (again using his special two-car arrangement) to Southern California, where he begins a series on mission architecture and documents the Tehachapi Loop and other features of the Southern Pacific Railroad for Huntington.

1878

Spends most of the summer in Yosemite; makes images in smaller format with wide-angle lens (pls. 27–28). New work appears to be a catharsis; Watkins displays a renewed and deeply personal involvement with the landscape. Becomes romantically involved with Frances ("Frankie") Sneade (1856–1945), a studio assistant.

1879

Opens new gallery at 427 Montgomery Street with William H. Lawrence as financial partner. Undertakes Mounts Lola and Round Top commission (pl. 29) for George Davidson (1825–1911) of the U.S. Coast and Geodetic Survey. On his fiftieth birthday marries Sneade; the bride is twenty-two.

1880

Takes major trip along the route of the Southern Pacific Railroad and makes numerous photographs of Southern California agriculture, fledgling oil industry, etc. (pls. 30–33). Travels as far as Tombstone,

Arizona, where he photographs mining and railroad development as well as the Casa Grande ruins. Returns to San Francisco by traveling wagon as he completes his mission series and makes views all along the Southern California coast from San Diego northward (pl. 34).

1881

In January photographs Kern County agricultural estates for court case (*Charles Lux v. James B. Haggin*); testifies on July 31, 1882. Daughter, Julia, born April 18. Visits Yosemite (probably for the last time) and completes a series showing the work of the Yolo Base Line project for Davidson and the U.S. Coast and Geodetic Survey.

1882

In the fall travels north by rail to Portland, Oregon, the Washington Territory, and Victoria, British Columbia, where he photographs Port Blakely and the Puget Sound area and makes overviews of Victoria and surrounding sites.

1883

In January photographs the Hotel Del Monte and numerous coastal sites in the Monterey/Carmel region. Exhibits at the Illinois State Fair on behalf of the California Immigration Commission. Travels to Oregon to photograph the Cascade Locks on the Columbia River. Son, Collis, born October 4.

1884

Bentley's Handbook and Ben Truman's *Illustrated Guide* published with photographic illustrations by Watkins. Returns to Oregon, then travels eastward into Idaho and Montana, where he photographs Yellowstone. Begins use of eight-by-ten-inch dry-plate negatives for field work.

1885

Exhibits at the New Orleans Exposition.

1887–88

Completes El Verano (a Sonoma County ranch) commission. Undertakes and completes massive series on Kern County agriculture; nearly one thousand negatives are produced.

1889

Exhibits Kern County photographs at the Mechanics' Fair, San Francisco.

1890

Photographs Montana copper mines in Butte and Anaconda using electric light and flashpowder underground. Eyesight failing and health weakening; suffers from vertigo. Details hardships in a series of letters to his wife. Photographs St. Ignatius College, San Francisco.

1891

Photographs Golden Gate and Golden Feather Mines, Butte County, California, in mammoth-size wet plates (the last commercial enterprise he completed). Relocates studio to 425 Montgomery Street.

1892–93

Suffers greatly from arthritis and diminished eyesight; experiences increasingly desperate economic privation as well.

1894

Obtains commission from Phoebe Hearst (1842–1919) to photograph her Hacienda del Pozo de Verona, near Livermore, California. After spending nearly a year on site, he is unable to complete the project. Relocates studio to 417 Montgomery Street.

1895–96

Unable to pay rent, Watkins lives with his family in an abandoned railroad car for eighteen months. As an act of kindness for past favors, Huntington deeds Capay Ranch in Yolo County to Watkins. Rents photographic rooms at 1249 Market Street.

1897–1900

Almost totally blind, Watkins is assisted in his photographic printing by his son and Charles B. Turrill (1854–1927), a photographer and Watkins's first biographer.

1903–4

Desperately poor, Watkins accepts financial aid from Turrill. Exhibits at the Lewis and Clark Exposition on behalf of the state of California but fails to receive financial compensation for his photographs.

1905

California State Library purchases examples of Watkins's historic photographs at Turrill's encouragement.

1906

Loses everything in the April 18 San Francisco earthquake and fire. Retires to Capay Ranch.

1909

Watkins is declared incompetent and placed under the custody of his daughter.

1910

Committed to the Napa State Hospital for the Insane. His wife begins to refer to herself as a "widow."

1916

Dies June 23 and is buried in an unmarked grave on the hospital grounds.

William Keith. *Commemorative Logotype,* designed 1868.
Stereograph card (verso), 8.3 × 17.1 cm.
84.XC.979.9370.

Editor	Gregory A. Dobie
Designer	Jeffrey Cohen
Production Coordinator	Stacy Miyagawa
Photographer	Ellen M. Rosenbery
Printer	C&C Offset Printing Co., Ltd.
	Hong Kong